LEARN TO DRAW

Disney · PIXAR

FINDING DORY

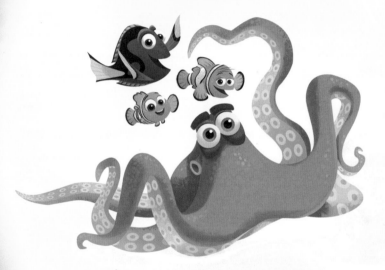

Illustrated by John Loter and The Disney Storybook Artists

THUNDER BAY
P · R · E · S · S
San Diego, California

Thunder Bay Press
An imprint of Printers Row Publishing Group
A division of Readerlink Distribution Services, LLC
10350 Barnes Canyon Road, Suite 100, San Diego, CA 92121
www.thunderbaybooks.com

Packaged by

Walter Foster Publishing
A division of Quarto Publishing Group USA Inc.
6 Orchard Road, Suite 100, Lake Forest, CA 92630
quartoknows.com

All notations of errors or omissions should be addressed to Thunder Bay Press, Editorial
Department, at the above address. All other correspondence (author inquiries, permissions)
concerning the content of this book should be addressed to Walter Foster Publishing, a division
of Quarto Publishing Group USA Inc., 6 Orchard Road, Suite 100, Lake Forest, CA 92630.

Publisher: Peter Norton

ISBN: 978-1-62686-857-1

Made in Shenzhen, China.

20 19 18 17 16 1 2 3 4 5

Disney · PIXAR
FINDING DORY

Art Studio
PROJECT BOOK

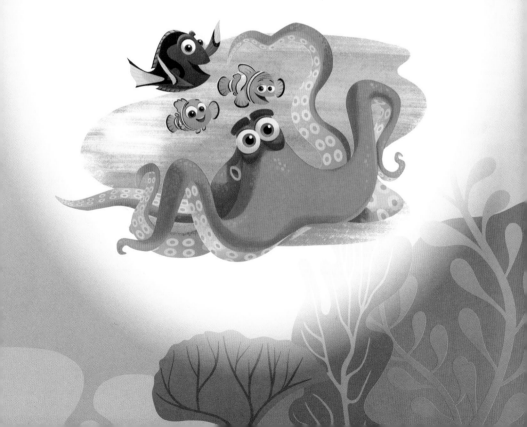

Table of Contents

Tools & Materials

Sketching Pencil

The sketching pencil in this kit has an HB lead hardness. This pencil won't smear easily like soft pencils do or scratch the surface of watercolor paper like hard pencils.

Colored Pencils

This kit contains seven colored pencils. Be sure to store them in the kit or a separate container. The lead in a colored pencil is brittle and likely to break inside the shaft if the pencil is dropped. This may not be immediately apparent, but will eventually render the pencil useless.

Fine-Tipped Black Marker

Use the fine-tipped black marker to ink your drawings. You can also experiment with ink, brush, dip, and ballpoint pens for different effects. Whenever possible, work with black waterproof ink for more permanent results.

Sharpener

You can achieve various effects depending on how sharp or dull your pencil is, but generally you'll want to keep your pencils sharp. A sharp point will provide a smooth layer of color.

Kneaded Eraser

The success of erasing colored pencil marks depends on two main factors: the color of the pencil line and the amount of pressure that was applied. Darker colors tend to stain the paper, making them difficult to remove, and heavy lines are difficult to erase, especially if the paper's surface has been dented.

Watercolor Paints

This kit contains three watercolor paints in tubes. Watercolor paints are commonly available in three forms—tubes, pans, and cakes. Most artists prefer tubes because the paint is already moist and mixes easily with water.

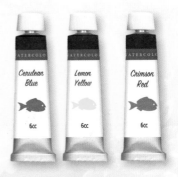

Paintbrushes

Many paintbrush styles are available, but two are most commonly used with watercolor—flat brush and round brush. A flat brush has bristles of equal length that produce even strokes. A round brush has bristles that taper to a point, which allows it to hold a good amount of water. You can also vary your pressure on the brush to create a variety of stroke widths.

Palette

The plastic palette in this kit features several wells for pooling and mixing your watercolors. It's easily cleaned with soap and water.

Colored Pencil Basics

Holding the Pencil

The way you grip the pencil directly impacts the strokes you create. Some grips will allow you to press more firmly on the pencil, resulting in dark, dense strokes. Others hinder the amount of pressure you can apply, rendering lighter strokes. Still others give you greater control over the pencil for creating fine details. Experiment with each of the grips below.

Photos © Quarto Publishing Group

Underhand Grip By cradling the pencil, you control it by applying pressure only with the thumb and index finger. This grip can produce a lighter line. Your whole hand should move (not just your wrist and fingers).

Conventional Grip For the most control, grasp the pencil about 1¹/₂" from the tip. Hold it the same way you write, with the pencil resting firmly against your middle finger. This grip is perfect for smooth applications of color, as well as for making hatch strokes and small, circular strokes.

Overhand Grip Guide the pencil by laying your index finger along the shaft. This is the best grip for strong applications of color made with heavy pressure.

Pressure

Your main tool for darkening the color with colored pencils is the amount of pressure you use. It is always best to start light so that you maintain the tooth (or the texture of roughness or smoothness) of the paper for as long as possible.

Light Pressure Here, color was applied by whispering a sharp pencil over the paper's surface. With light pressure, the color is almost transparent.

Medium Pressure This middle range creates a good foundation for layering.

Heavy Pressure Pushing down on the pencil flattens the paper's texture, making the color appear almost solid.

Watercolor Basics

Watercolor paint straight from the tube is generally too dry and thick to work with, so you'll need to dilute it with water. The less water you use, the more intense the color will be.

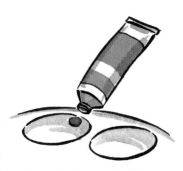
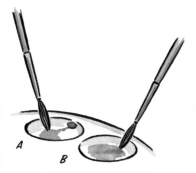

Starting Out Small Watercolors are very concentrated—a little goes a long way. Start by squeezing out a pea-sized amount of paint into one of the wells of your mixing palette.

Diluting the Paint Dip your brush in clean water, and then mix the water with the paint. Keep adding water until you achieve the dilution level you want (A). You can also transfer some of the paint to a separate well for mixing with other colors or for diluting the paint further (B).

Dilution Chart Here's how brilliant red looks in four different dilution levels, from slightly diluted to very diluted.

Testing Your Colors

It's always a good idea to have a piece of scrap paper handy to test your colors before applying them to your painting.

Color Basics

Color can help bring your drawings to life, but first it helps to know a bit about color theory. There are three primary colors: red, yellow, and blue. These colors cannot be created by mixing other colors. Mixing two primary colors produces a secondary color: orange, green, and purple (or violet). Mixing a primary color with a secondary color produces a tertiary color: red-orange, red-purple, yellow-orange, yellow-green, blue-green, and blue-purple. Reds, yellows, and oranges are "warm" colors; greens, blues, and purples are "cool" colors.

The Color Wheel

A color wheel is useful for understanding relationships between colors. Knowing where each color is located on the color wheel makes it easy to understand how colors relate to and react with one another.

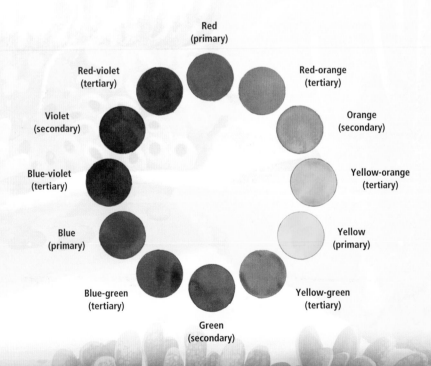

Red (primary)

Red-violet (tertiary)

Red-orange (tertiary)

Violet (secondary)

Orange (secondary)

Blue-violet (tertiary)

Yellow-orange (tertiary)

Blue (primary)

Yellow (primary)

Blue-green (tertiary)

Yellow-green (tertiary)

Green (secondary)

Easy Color Combinations

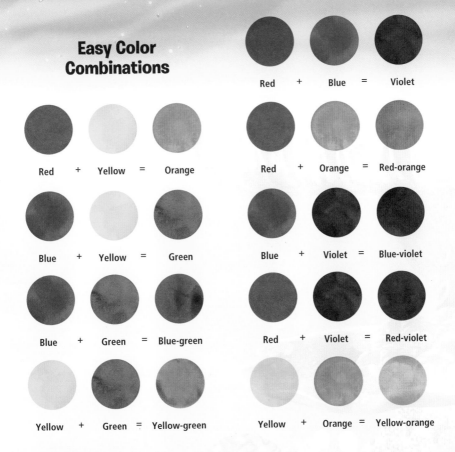

Red + Blue = Violet

Red + Yellow = Orange

Red + Orange = Red-orange

Blue + Yellow = Green

Blue + Violet = Blue-violet

Blue + Green = Blue-green

Red + Violet = Red-violet

Yellow + Green = Yellow-green

Yellow + Orange = Yellow-orange

Blending Colored Pencils

Colored pencils are transparent by nature, so instead of "mixing" colors as you would for painting, you create blends directly on the paper by layering colors on top of one another.

Adding Color to Your Drawing

Some artists draw directly on illustration board or watercolor paper and then apply color to the original pencil drawing. However, if you are a beginning artist, you might opt to preserve your original pencil drawing by making several photocopies and applying color to a photocopy. This way, you'll always have your original drawing in case you make a mistake or you want to experiment with different colors or mediums.

How to Use This Book

Usually artists draw characters in several steps. Sometimes the steps are different, depending on what you're drawing. The important thing to remember is to start simply and add details later. The blue lines show each new step, and the black lines show what you've already drawn.

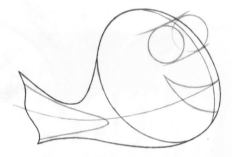

Step 1

The first thing you'll draw are guidelines to help position the features of the character.

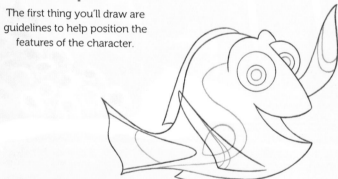

Step 2

Next you'll start to add details to your drawing. It will take several steps to add all the details.

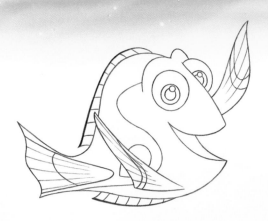

Step 3

When you finish all the details of your drawing, you can go back and erase your guidelines. You can also darken your lines with a pen or marker.

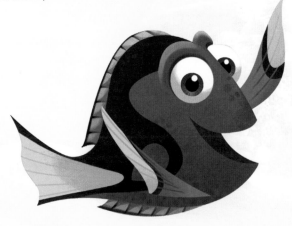

Step 4

Now add color!

The Story of
Finding Dory

One year after Marlin and Dory's journey across the
ocean to find Nemo, the three fish are living happily together
as neighbors on the coral reef. As Mr. Ray's new teaching
assistant, Dory accompanies Nemo's class on a field trip to
watch a stingray migration, where they learn how some animals
have a natural instinct to return home. Distracted by long-lost
childhood memories, Dory is swept into the undertow. Nemo
finds her, disoriented and lying in the sand, mumbling "Jewel
of Morro Bay, California." On the way back home, Dory insists
she's remembered something important. Nemo mentions the
phrase "Jewel of Morro Bay, California," and suddenly Dory has
a flood of memories. Dory has a family! She even remembers
her parents' names: Charlie and Jenny. After much convincing—
Marlin isn't too happy about leaving the reef so soon after
their last adventure—Nemo persuades his dad to help
Dory find her family, and the three leave the reef together,
heading toward the Pacific Coast.

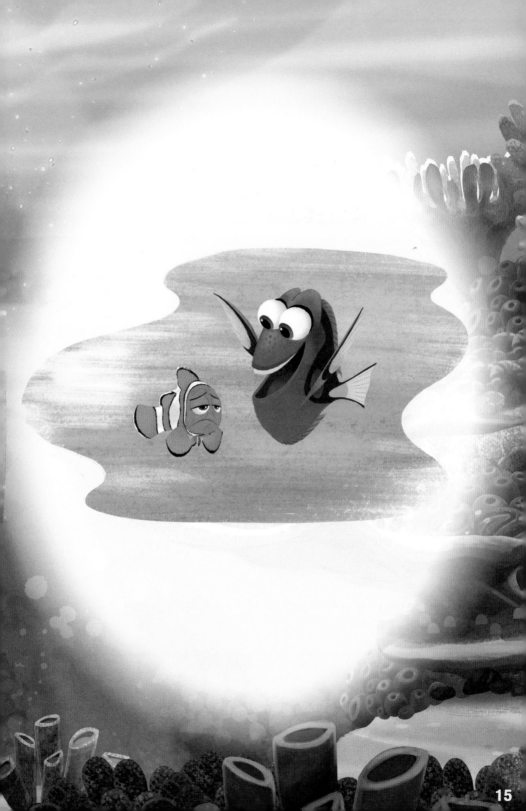

Dory, Marlin, and Nemo meet both old and
new friends along their journey, including two
righteous sea turtles, Crush and Squirt, who help them surf
the currents all the way to California! Dory's not sure where
she'll go once she gets there, but she's not too worried—
after all, her motto is "just keep swimming!" But after a
run-in with a group of local hermit crabs and a giant squid,
Dory is scooped up by staffers at the Marine Life Institute,
an aquarium in Morro Bay, California, whose mission is to
rescue, rehabilitate, and release the coast's sickest fish and
sea mammals. Separated from Marlin and Nemo, who've
been left outside the Institute, Dory finds herself trapped
inside a quarantine tank with a tag clipped to her fin.

Inside, Dory meets Hank, a seven-legged octopus. He
reluctantly offers to help her find her parents in exchange
for her tag. You see, Hank has one mission: He wants to be
transferred to the Institute's much quieter sister facility in
Cleveland. Dory's tag is his ticket out.

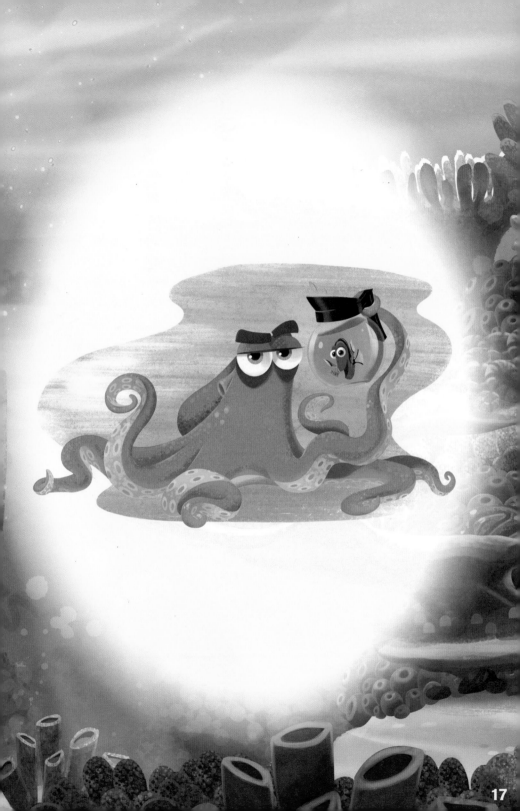

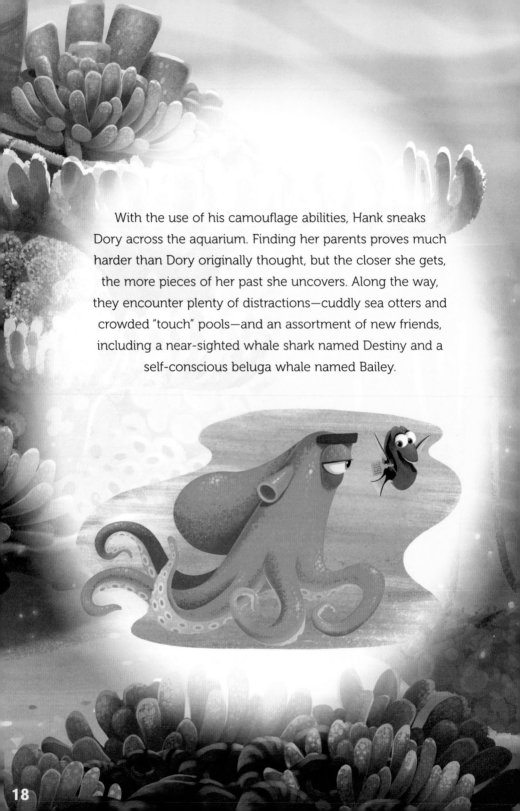

With the use of his camouflage abilities, Hank sneaks Dory across the aquarium. Finding her parents proves much harder than Dory originally thought, but the closer she gets, the more pieces of her past she uncovers. Along the way, they encounter plenty of distractions—cuddly sea otters and crowded "touch" pools—and an assortment of new friends, including a near-sighted whale shark named Destiny and a self-conscious beluga whale named Bailey.

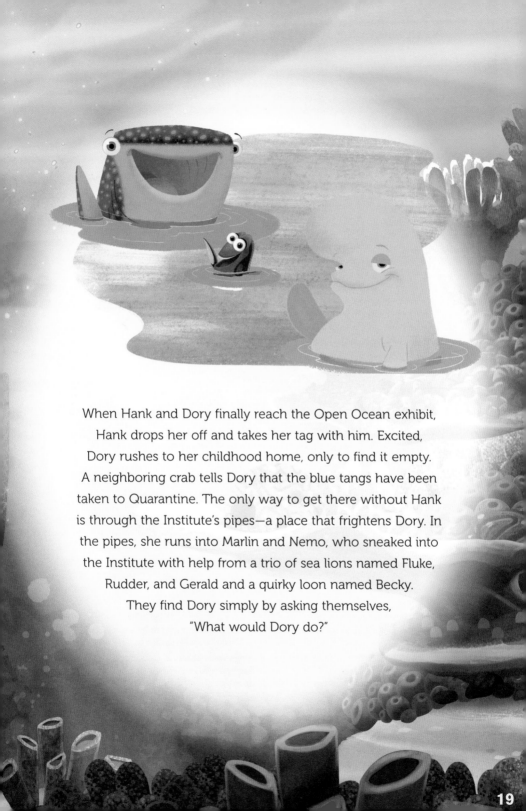

When Hank and Dory finally reach the Open Ocean exhibit,
Hank drops her off and takes her tag with him. Excited,
Dory rushes to her childhood home, only to find it empty.
A neighboring crab tells Dory that the blue tangs have been
taken to Quarantine. The only way to get there without Hank
is through the Institute's pipes—a place that frightens Dory. In
the pipes, she runs into Marlin and Nemo, who sneaked into
the Institute with help from a trio of sea lions named Fluke,
Rudder, and Gerald and a quirky loon named Becky.
They find Dory simply by asking themselves,
"What would Dory do?"

Back in Quarantine, Dory, Marlin, and Nemo seek out Hank, who's about to get on the truck to Cleveland. He helps Dory find the blue tangs, but they have bad news—her parents aren't there. Hank scoops up Dory but drops her when a staffer unexpectedly grabs him. He watches in horror as she slips through a drain that leads to the ocean.

Dory suddenly finds herself alone and lost outside the Institute. Just as she's starting to feel overwhelmed, she asks herself, "What would Dory do? What would I do?" She looks around and spots a trail of shells that lead to her parents' new home. They've been right outside the Institute all this time, waiting for Dory! Yet Dory's journey isn't over—Marlin and Nemo are still stuck inside the truck, on their way to Cleveland with Hank. She has to get them back! With the help of her new friends and parents, Dory discovers the true meaning of family and sets off to find Hank and the two clownfish.

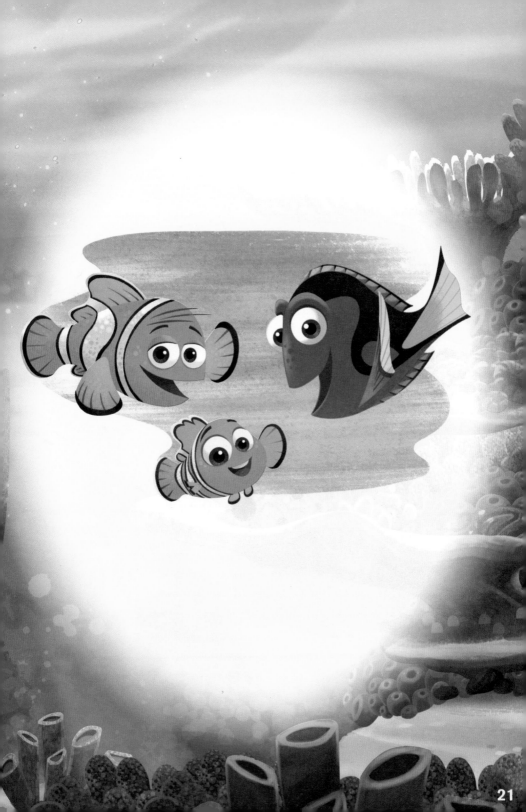

Size Chart

From clownfish to whale sharks, the ocean is filled with creatures of all shapes and sizes.

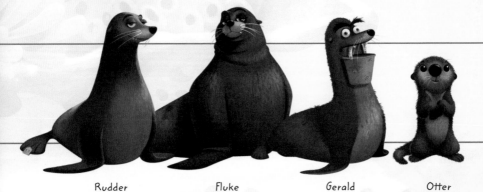

Bailey

Rudder Fluke Gerald Otter

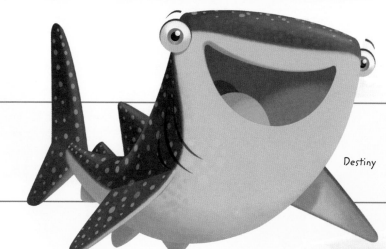

Destiny

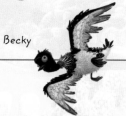

Becky

Nemo　　Marlin　　Jenny　　Dory　　Charlie

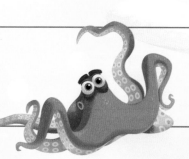

Hank

Dory

Dory is wide-eyed, sweet, and a bit forgetful. She suffers from short-term memory loss, which she'll tell you right away—and then promptly forget and tell you again. Years ago, when she was just a baby, Dory embarked on an adventure that led her far away from her parents and the only home she's ever known.

Now that she's older, Dory's sunny personality hides her real problem—Dory doesn't remember her family. Of course, she has a new family in her clownfish neighbors, Marlin and Nemo, but something is still missing. Although Dory doesn't quite know what she's searching for or where to find it, she lets her instincts lead the way.

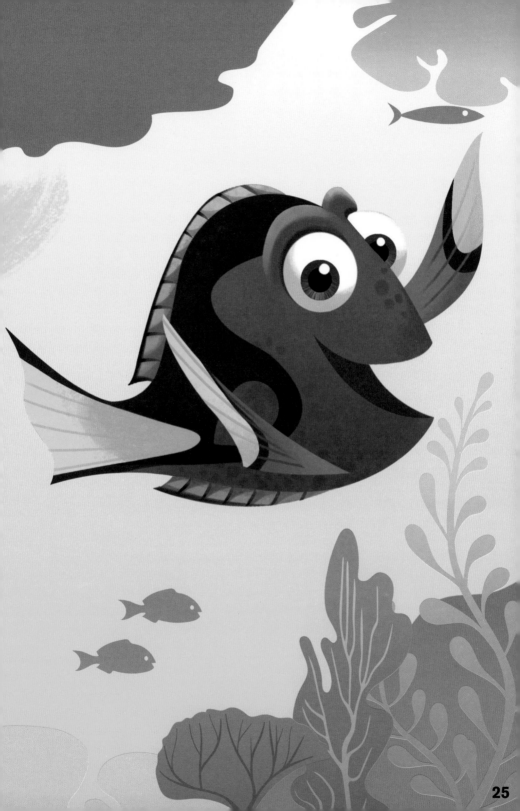

Baby Dory

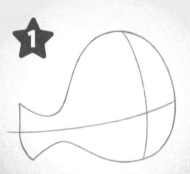

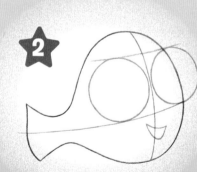

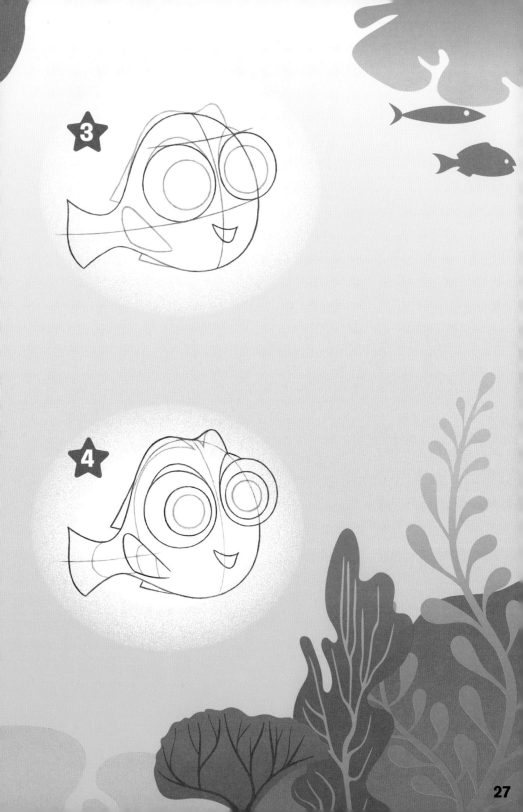

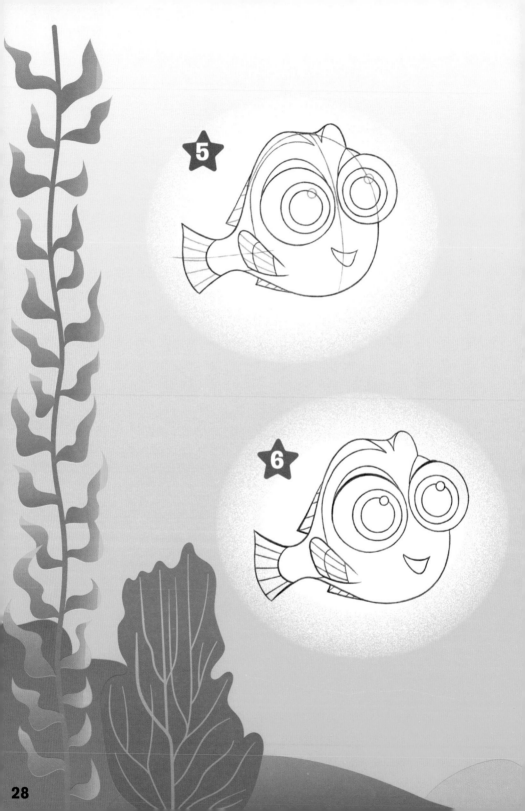

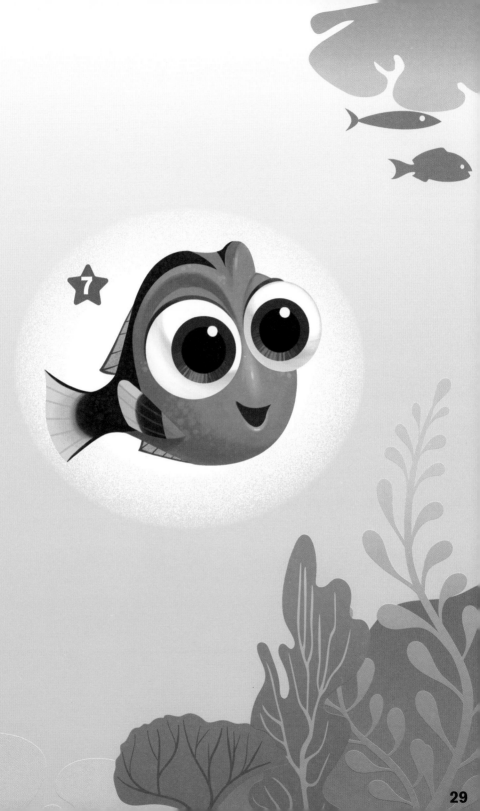

Try drawing Baby Dory here:

Flat

Flat

Keep the edges of her fins rather flat, don't make them too round

She has a round little nose that curves inward

Dory

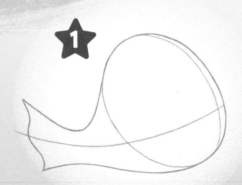

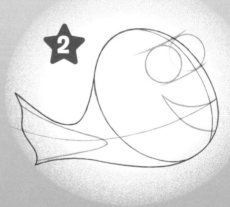

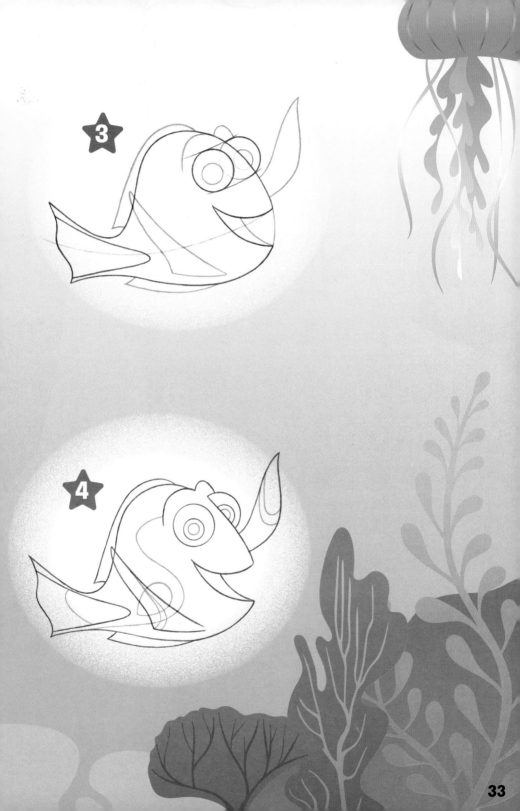

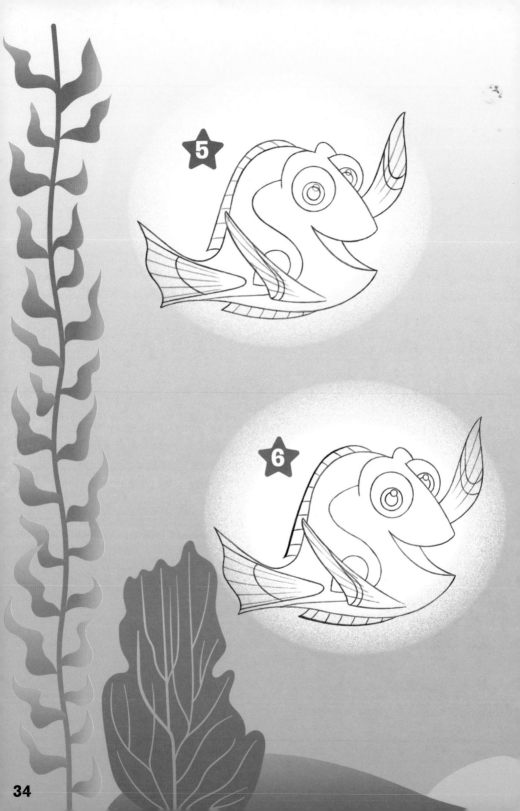

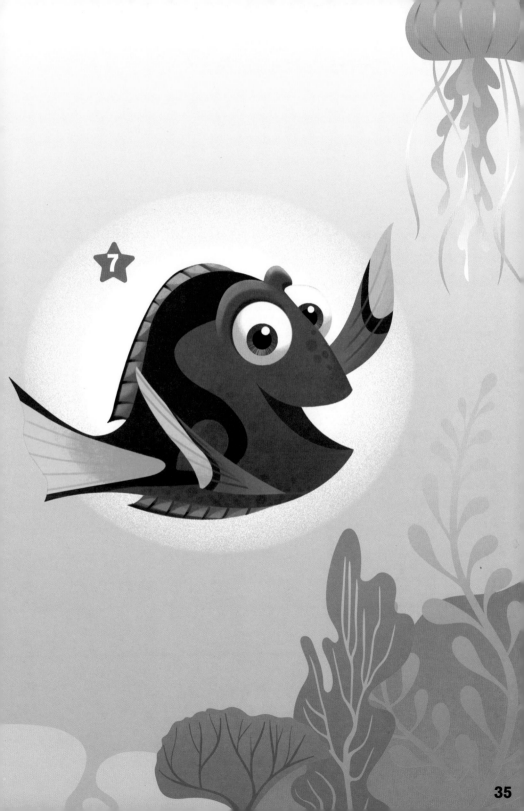

Try drawing Dory here:

From the side, Dory's body is shaped like a football

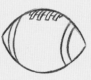

YES! curved freckle pattern

NO! too straight

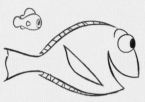

Dory is just over 4 times the size of Nemo

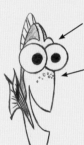

From the front, Dory's stripe defines where her "eyebrows" end

Freckles follow the curved bridge of her "nose"

Side fins are straight on top...

3 rays

...and curved on bottom

Charlie & Jenny

Always ready with a joke, Dory's father, Charlie, takes nothing more seriously than protecting his memory-challenged daughter. He teaches Dory how to make the most of life with her short-term memory and how to have a little fun along the way. Jenny, Dory's mother, is a cheerful and caring blue tang. But make no mistake—she is one fierce fish. Her maternal love and wisdom are steadfast, whether she's by Dory's side or an ocean away.

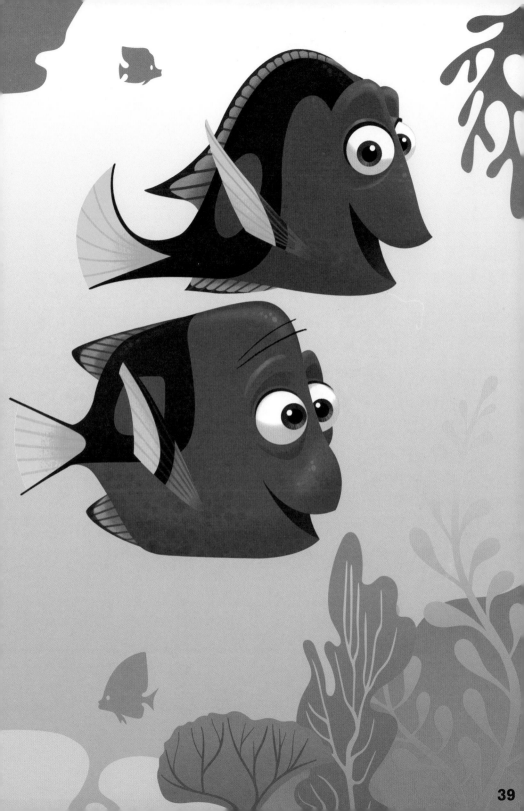

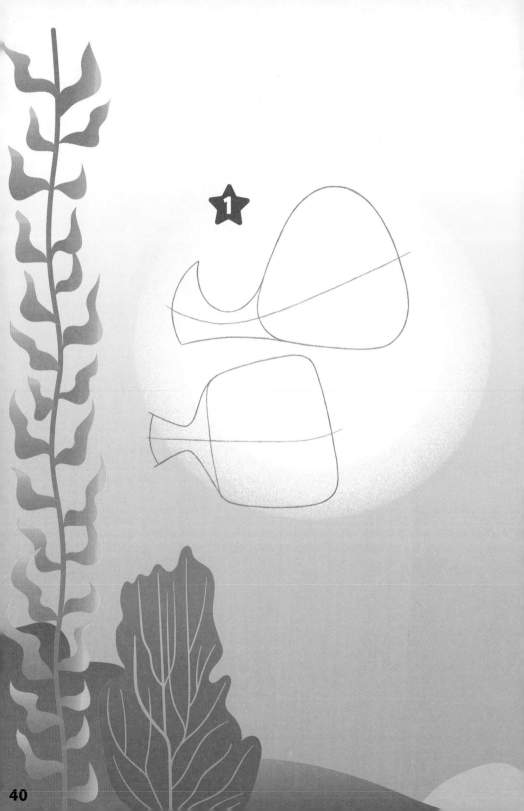

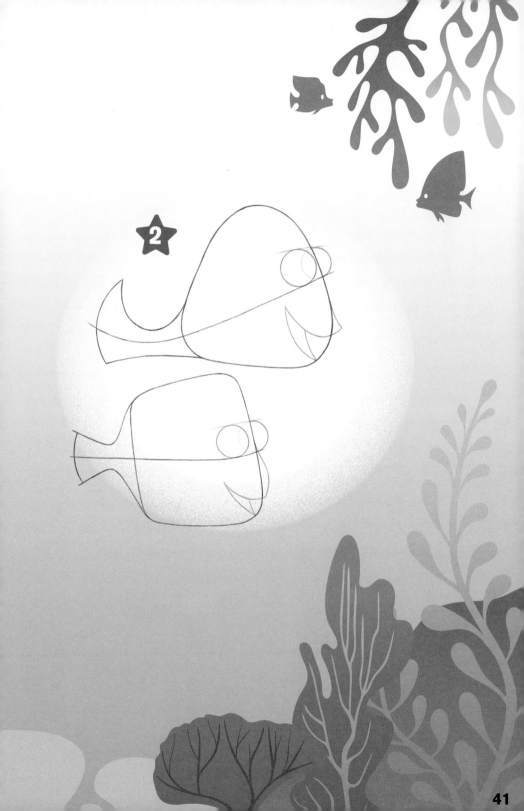

2

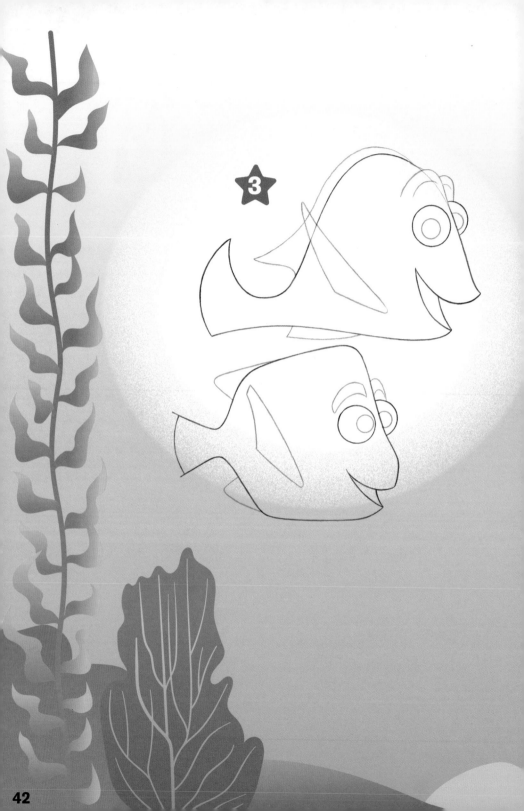

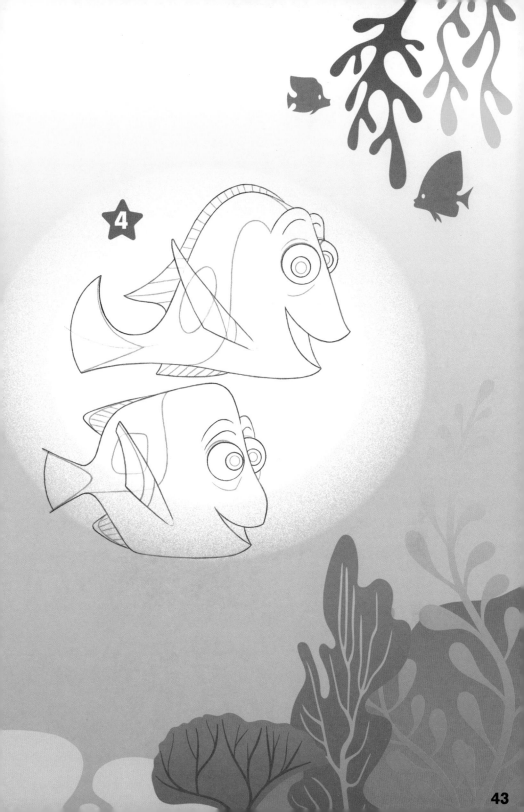

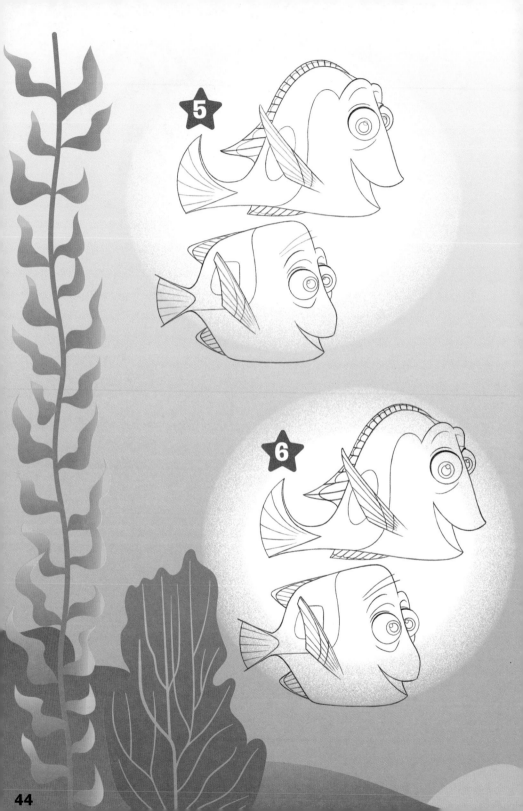

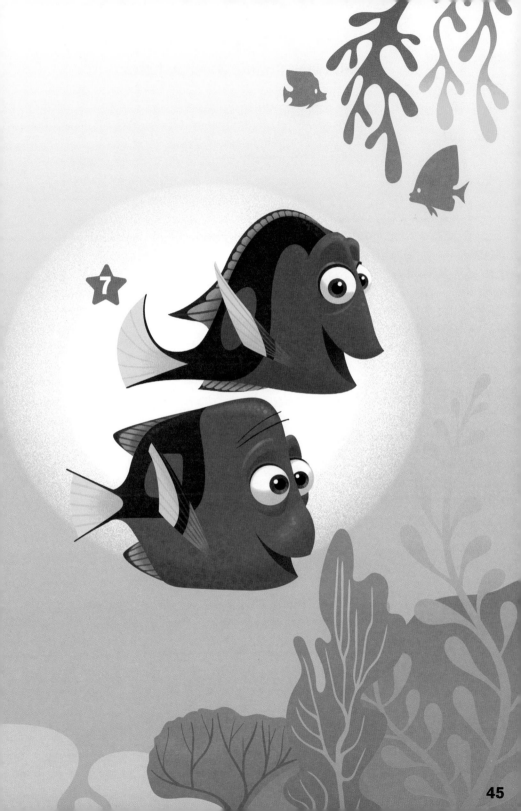

Try drawing Charlie & Jenny here:

The nose and mouth shapes for
Dory and her family differ:

Jenny Dory Charlie

Unlike Charlie, Jenny is flat
on the bottom and very curvy
on top (like a roller coaster)

Large eyebrows and
forehead lines that
double as a "comb-over"

Charlie is slightly
cross-eyed

Marlin

Marlin is a not-so-funny clownfish who's been known to go a little overboard on his mission to protect his son, Nemo. But can you blame him? The last time he let Nemo out of his sight, Nemo was fishnapped by a scuba-diving dentist and taken all the way to Sydney, Australia! With Dory's help, Marlin found Nemo and brought him home. Now he's joining Dory on an adventure to find her own family, but first he'll have to get over letting the forgetful blue tang lead the way.

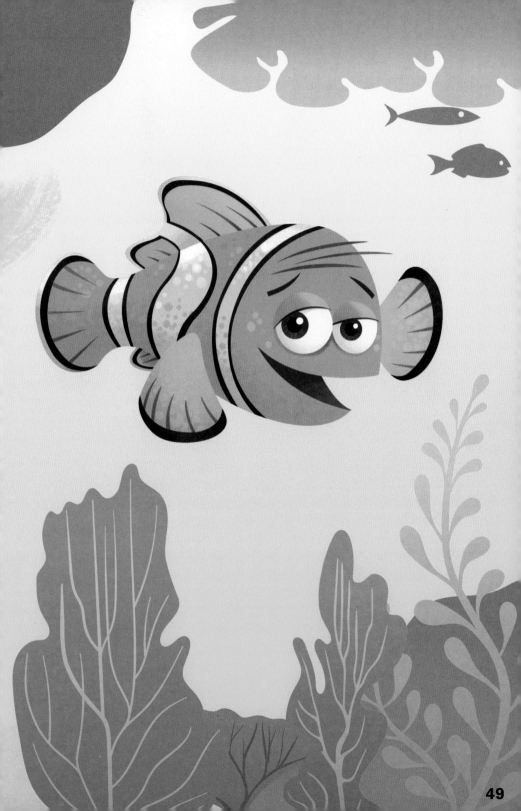

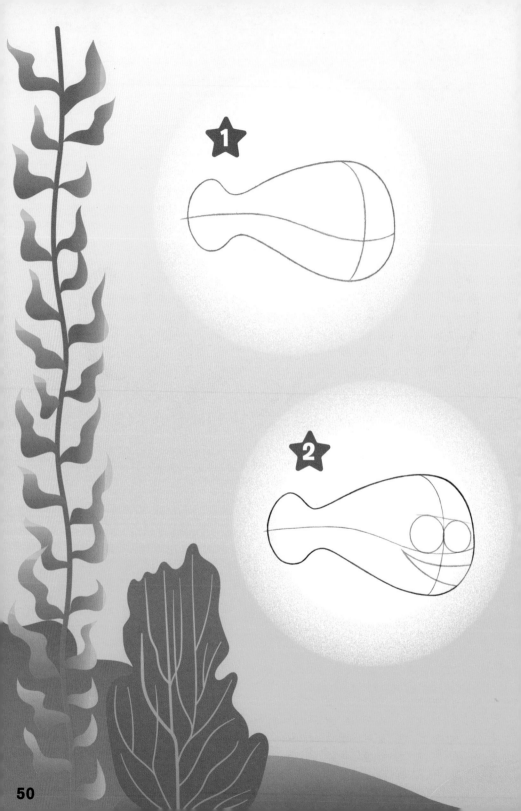

50

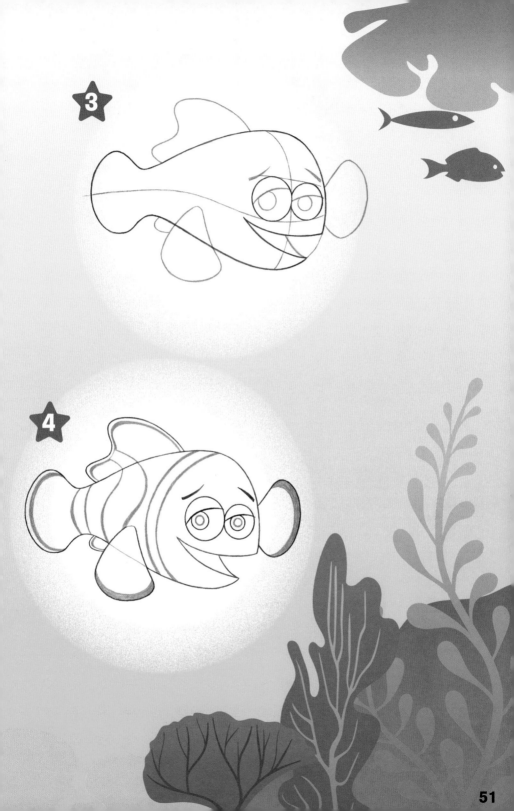

3

4

51

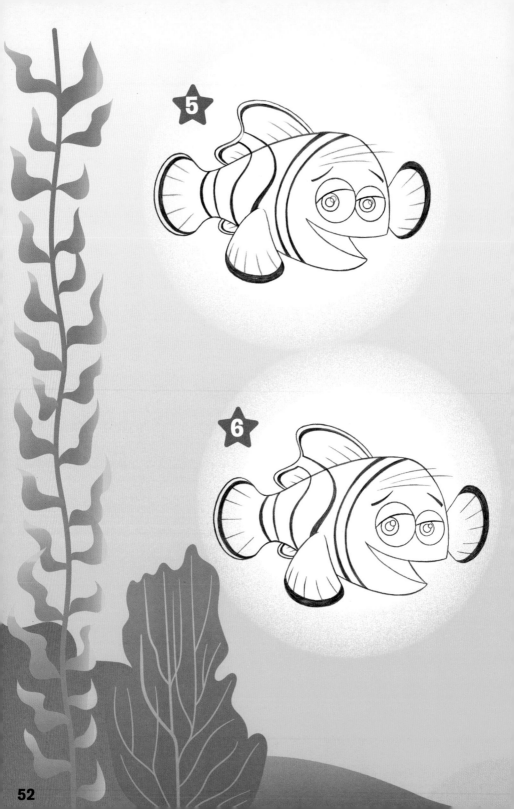

52

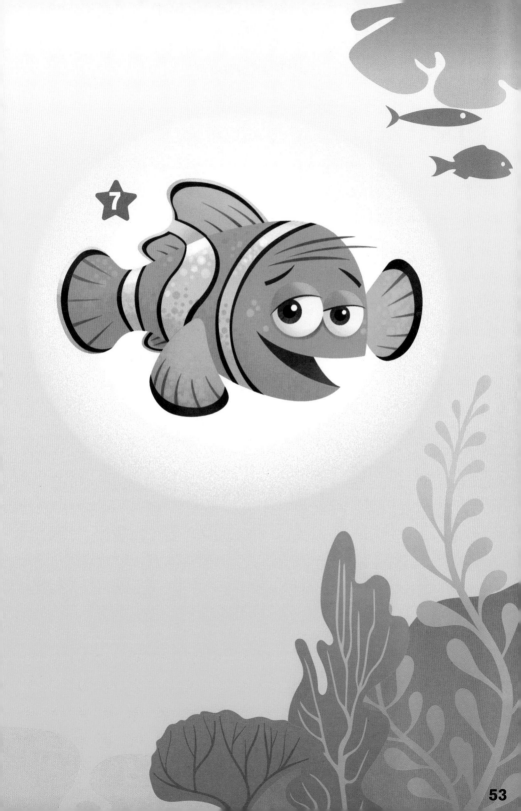

Try drawing Marlin here:

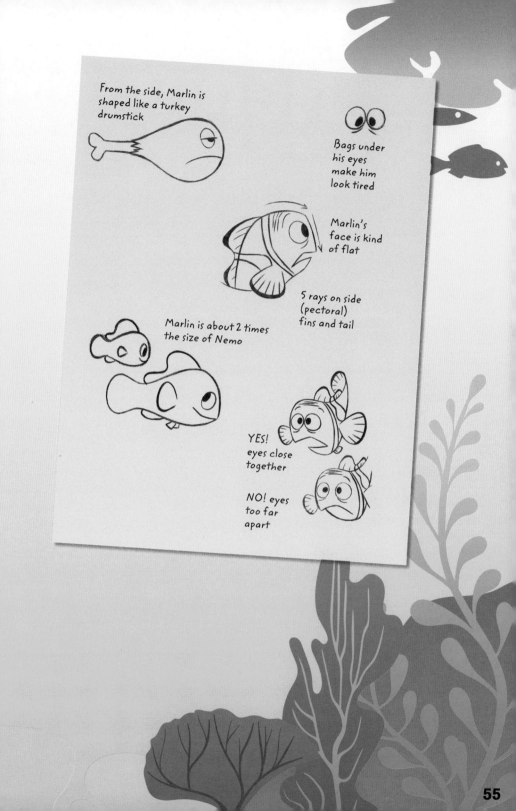

From the side, Marlin is shaped like a turkey drumstick

Bags under his eyes make him look tired

Marlin's face is kind of flat

5 rays on side (pectoral) fins and tail

Marlin is about 2 times the size of Nemo

YES! eyes close together

NO! eyes too far apart

Nemo

After his last adventure, Nemo is back to being a normal clownfish, attending school and living on the reef with his dad and Dory. But after Dory starts remembering pieces of her past and the family she's lost, Nemo wants nothing more than to help reunite them, even if it means crossing the ocean again. He believes in his blue tang friend—he knows what it's like to be different.

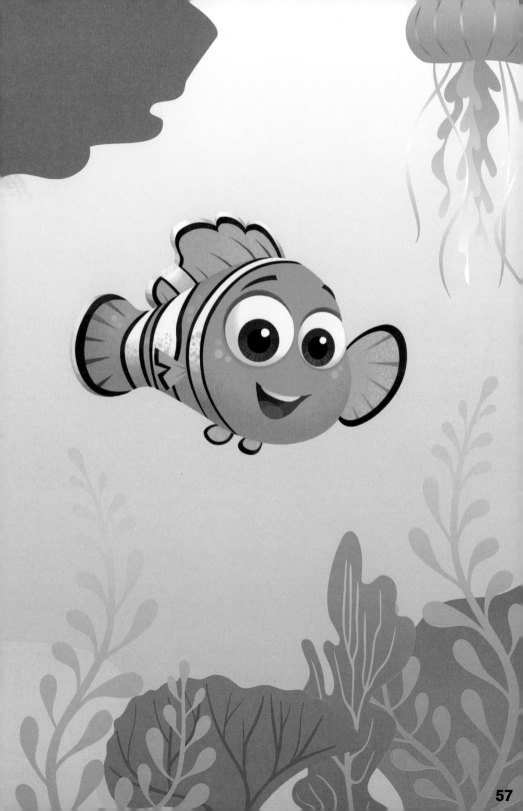

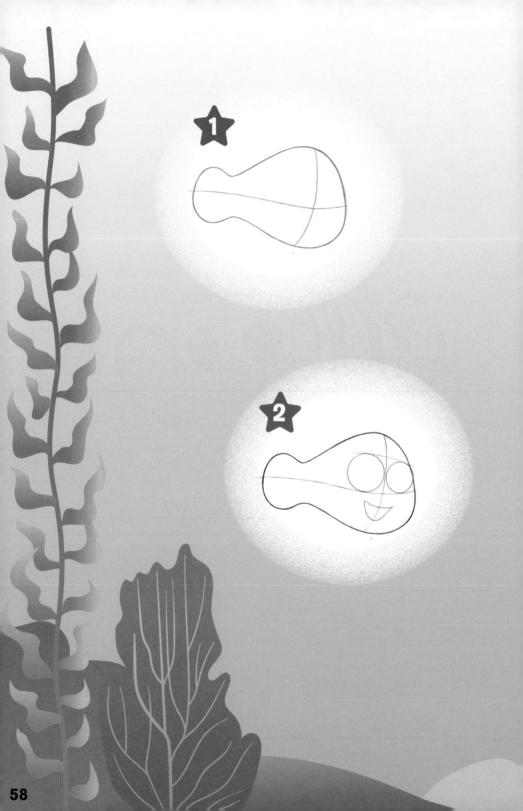

58

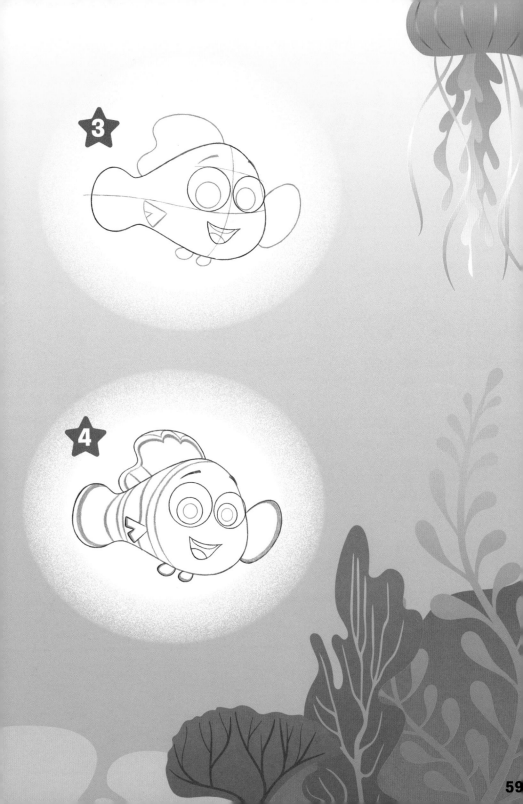

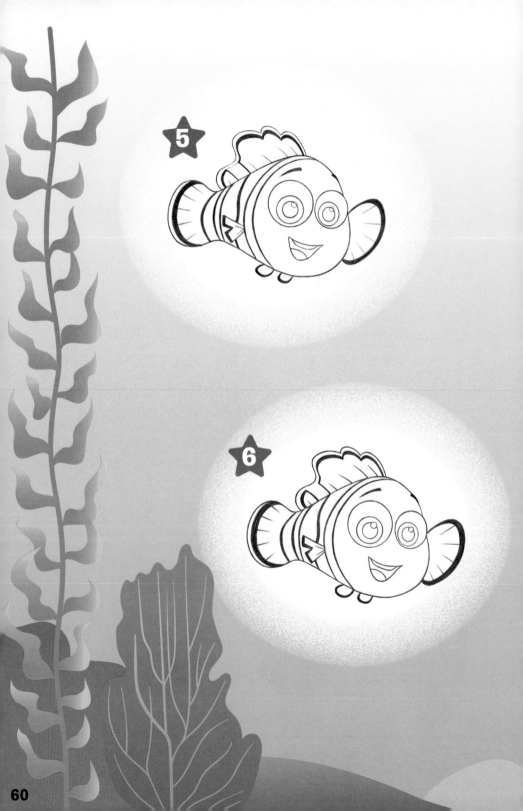

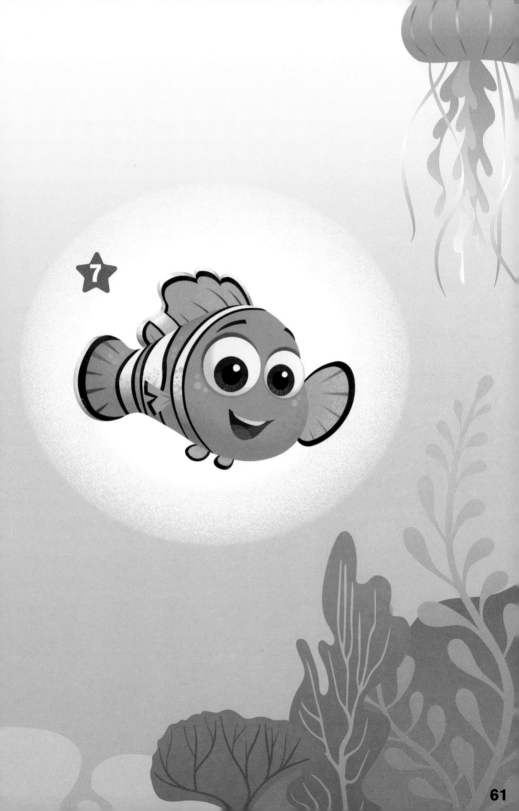

Try drawing Nemo here:

From the side,
Nemo is shaped like
a Goldfish® cracker

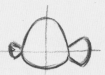

From the front,
his body looks
like a gumdrop

YES! top (dorsal)
fin is 2 different
shapes pointing at
different angles

NO! too even;
too upright

YES! rays
follow
curve of
fin

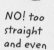

NO! too
straight
and even

Top fin is same
height as 1 eye

Nemo is about
4 "eyes" tall,
including top fin

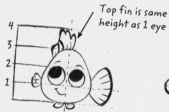

4
3
2
1

YES! bottom fins are set
apart from each other

NO! fins look
like bow tie

Hank

Hank is an octopus living in the Marine Life
Institute. Okay, technically he is a *septopus*—
he lost a tentacle somewhere along the way.
But Hank's missing limb has made him no less
competent than his eight-legged peers. He has
one mission: to be transferred to the Institute's
much quieter facility in Cleveland. Despite
all three of his hearts, Hank can be a bit of a
grump, but even he's no match for one little
blue tang's enduring positivity.

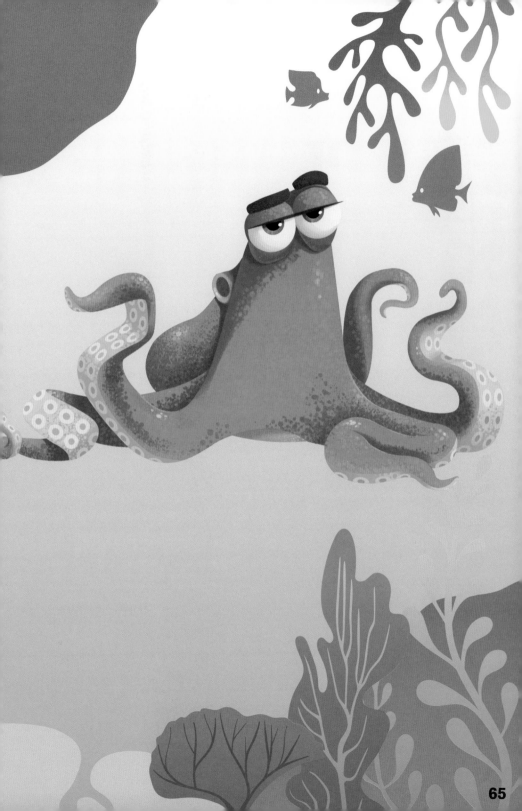

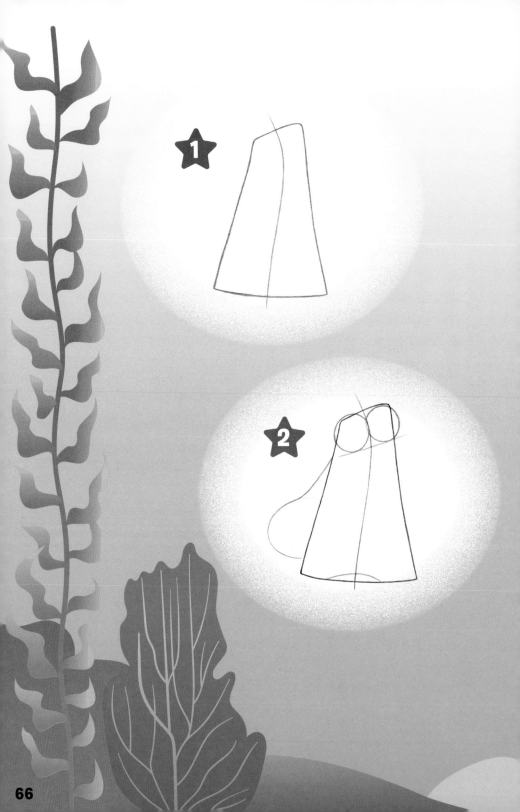

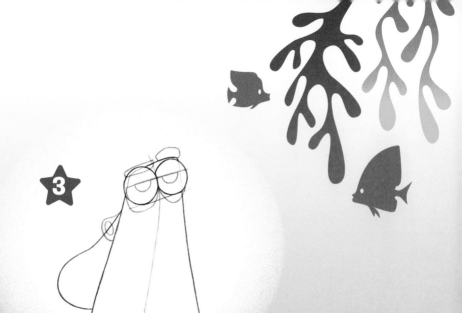

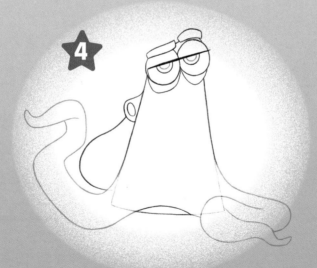

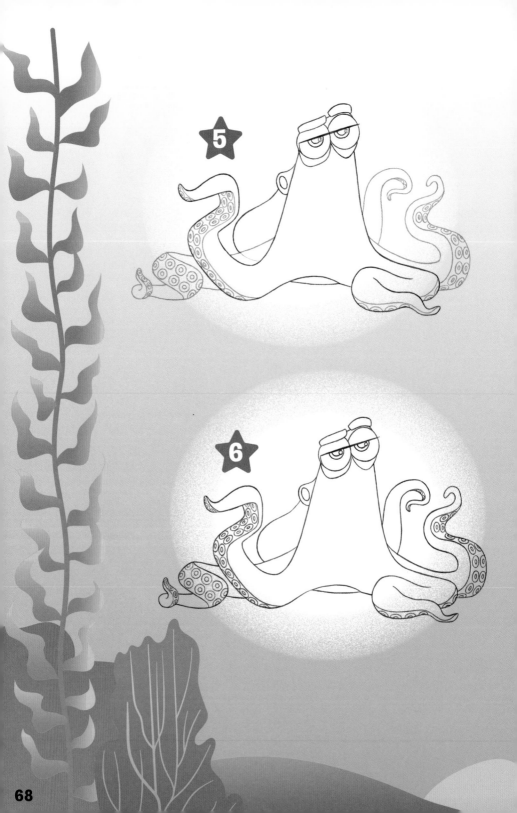

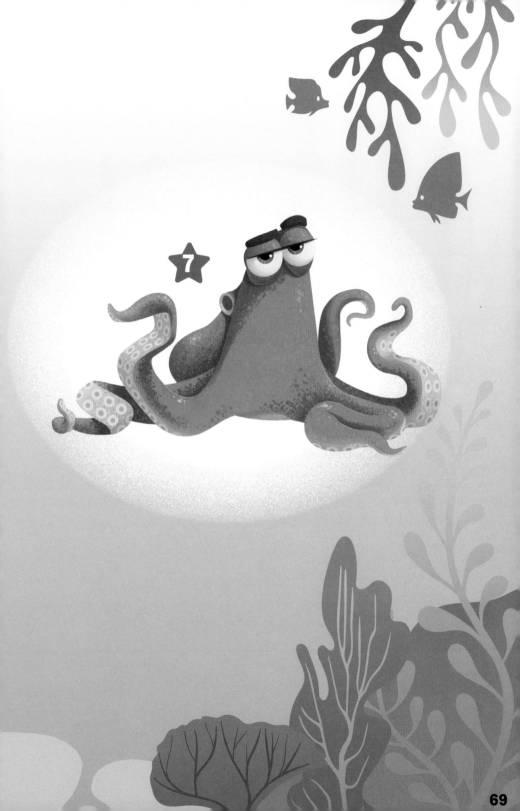

Try drawing Hank here:

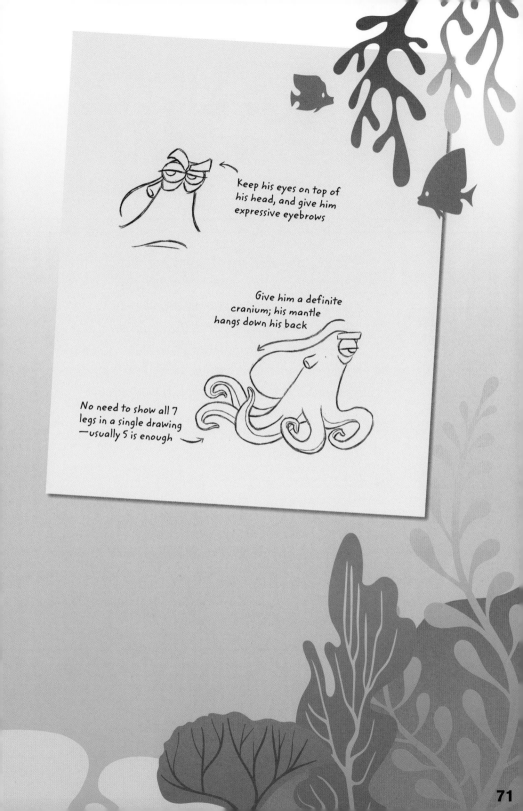

Keep his eyes on top of his head, and give him expressive eyebrows

Give him a definite cranium; his mantle hangs down his back

No need to show all 7 legs in a single drawing —usually 5 is enough

Destiny

Destiny is the Marine Life Institute's rescued whale shark. She's not too confident in her swimming skills, as her bad eyes make navigating the big blue a challenge. When she was little, Destiny communicated (in whale, of course) with a young blue tang through the Institute's pipes, but when their conversations suddenly stopped, Destiny worried she'd never hear from her friend again.

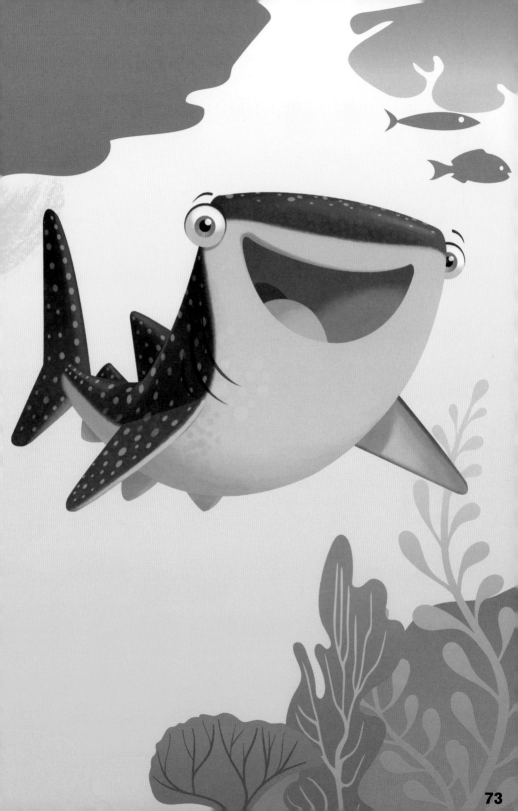

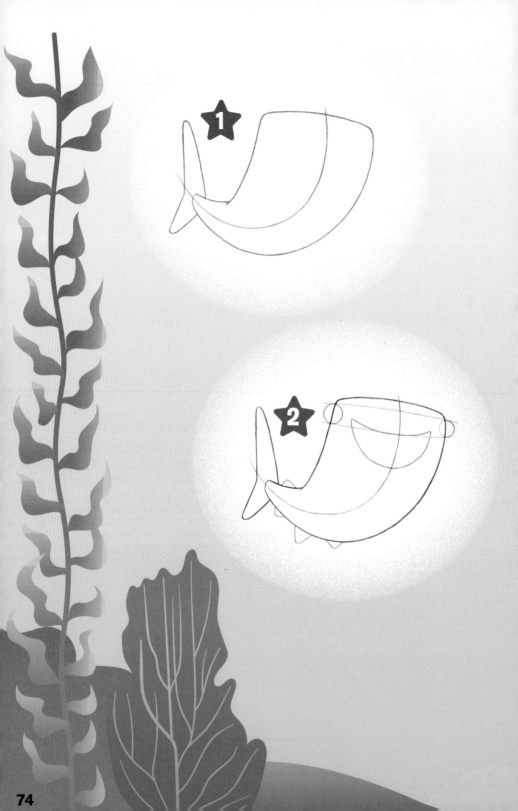

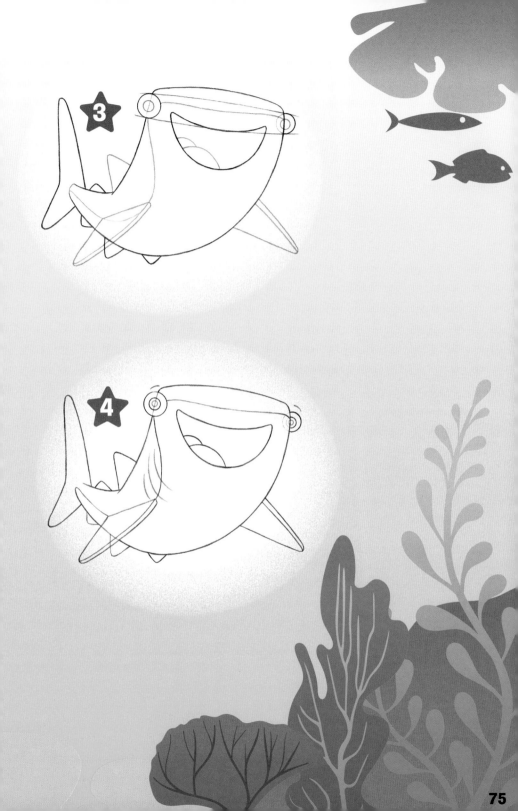

Try drawing Destiny here:

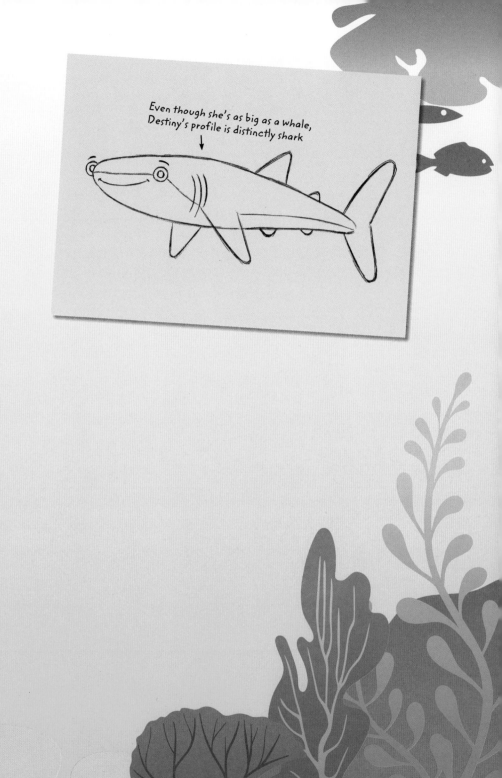

Even though she's as big as a whale, Destiny's profile is distinctly shark

Bailey

Bailey is a beluga whale living at the Marine
Life Institute. He was brought to the facility
for a head injury. Though the doctors agree
that there is nothing wrong with Bailey,
he doesn't believe them for a second.
He's convinced the injury damaged his
echolocation abilities. Why, just look how
swollen his massive cranium is! Of course,
the size of his head is perfectly normal for a
beluga, but Bailey doesn't know that.

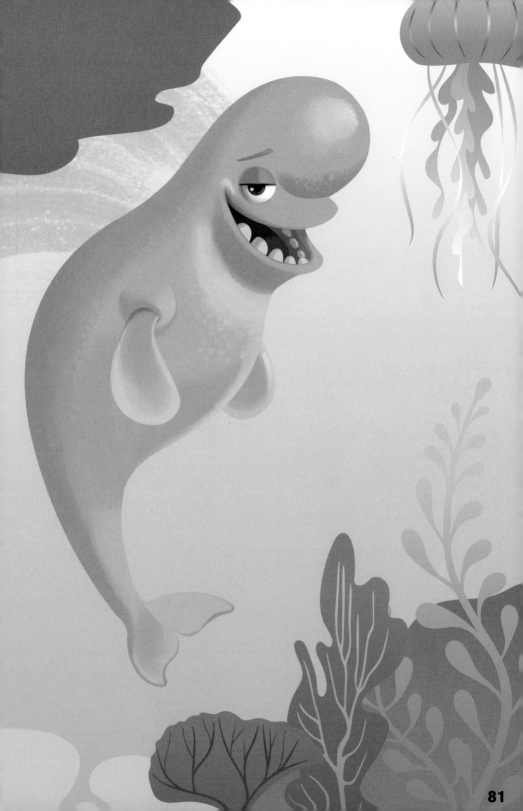

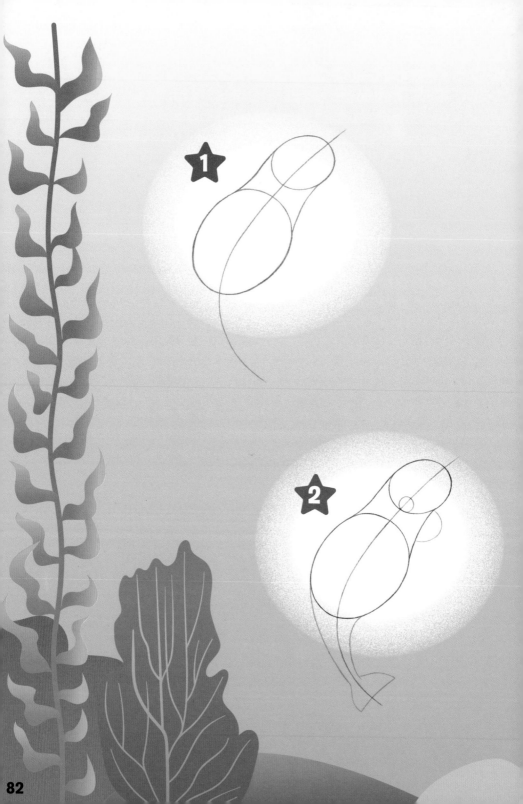

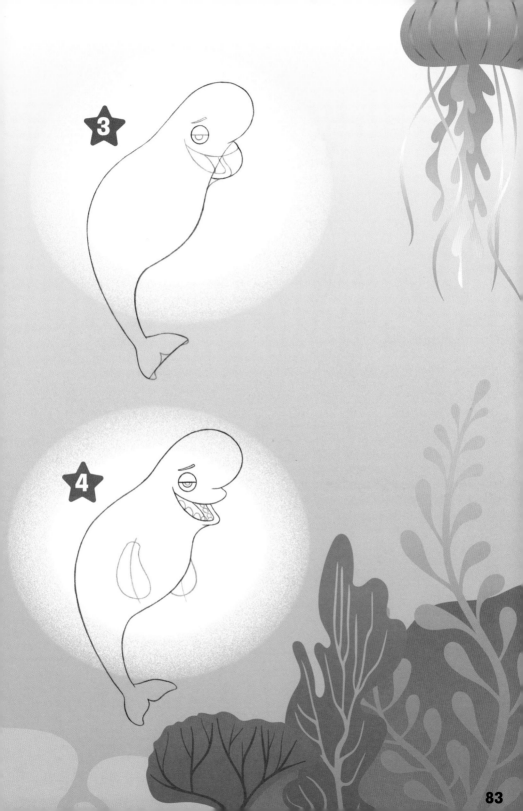

3

4

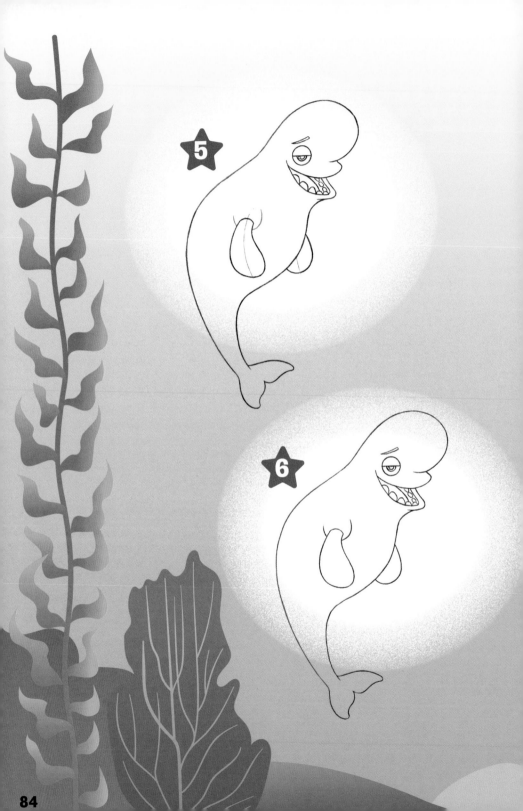

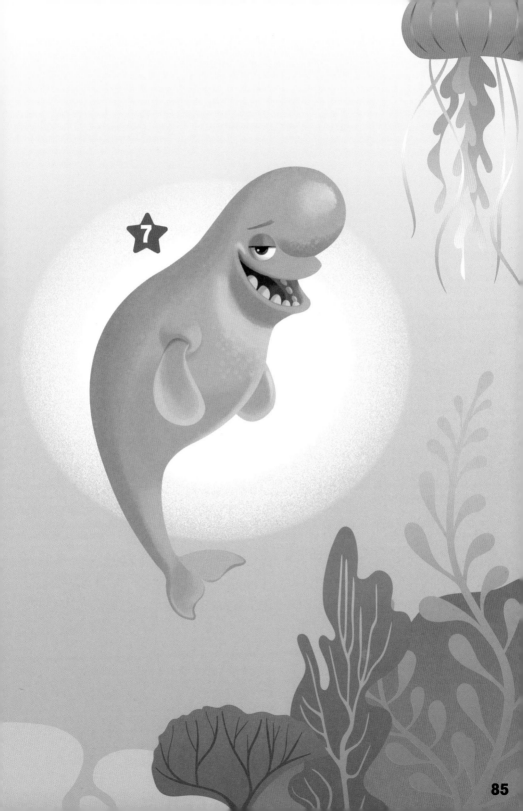

Try drawing Bailey here:

Bailey's head is large, but don't make it...

...too large

...or too small

Aaah, just right!

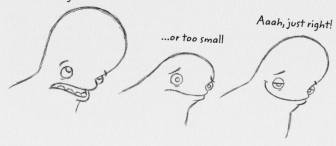

Fluke

Fluke is a lazy sea lion who spends his days sleeping on a warm rock outside the Marine Life Institute. Fluke shares his rock with Rudder, his pal—but that other irritating sea lion, Gerald, can shove off and find his own!

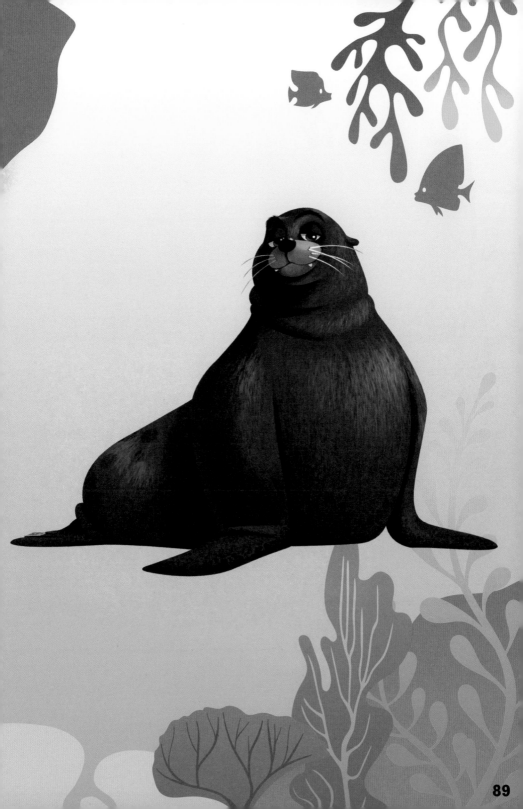

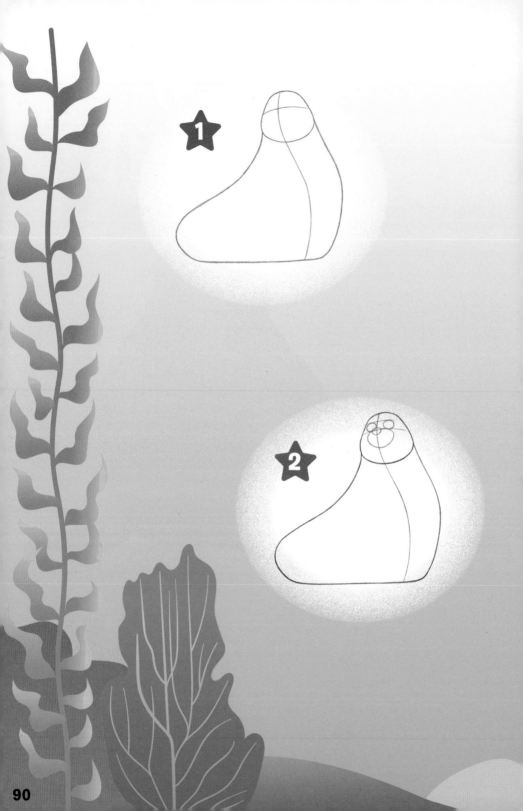

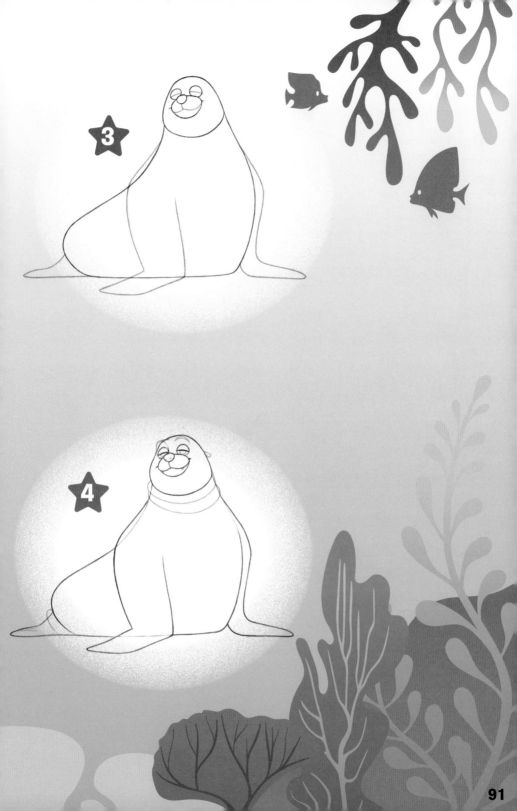

91

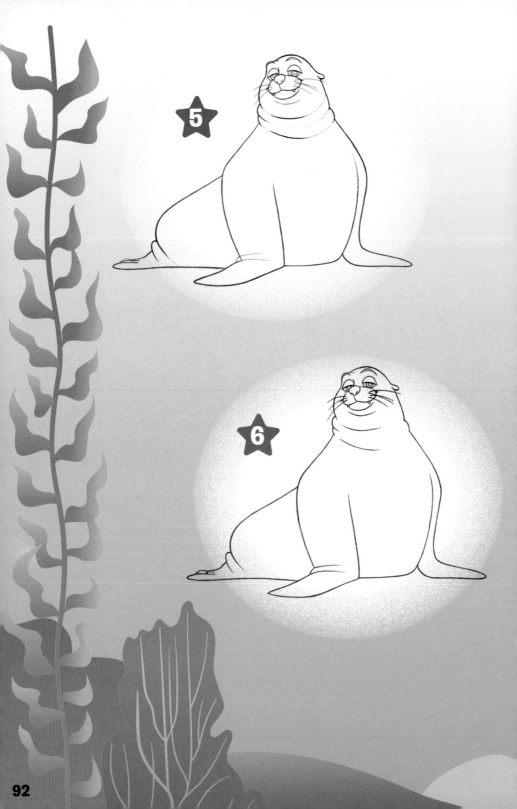

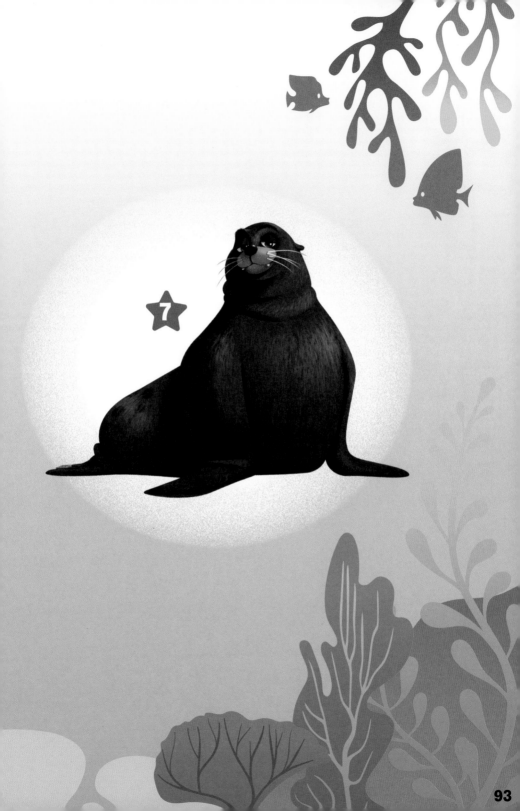

Try drawing Fluke here:

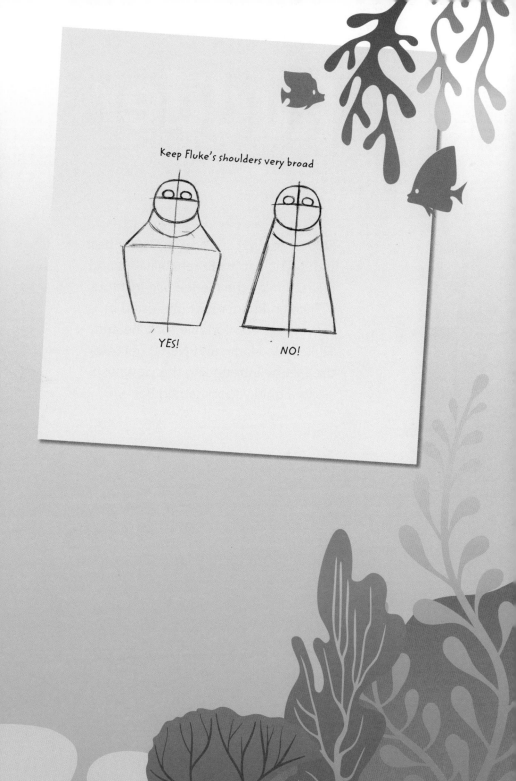

Keep Fluke's shoulders very broad

YES!

NO!

Rudder

Rudder, another sea lion, is Fluke's best friend. The pair were rehabilitated and released from the Marine Life Institute. Though Rudder isn't interested in leaving his comfortable rock, he and Fluke help Marlin and Nemo get into the MLI by introducing the clownfish to a quirky loon named Becky.

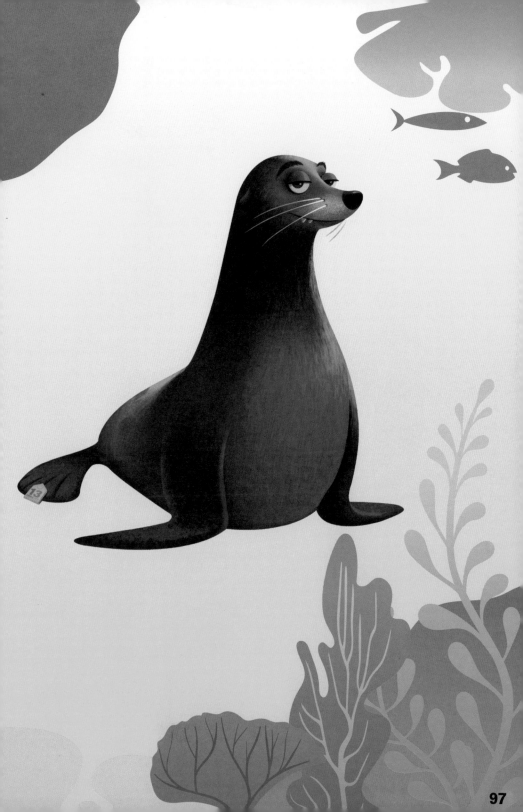

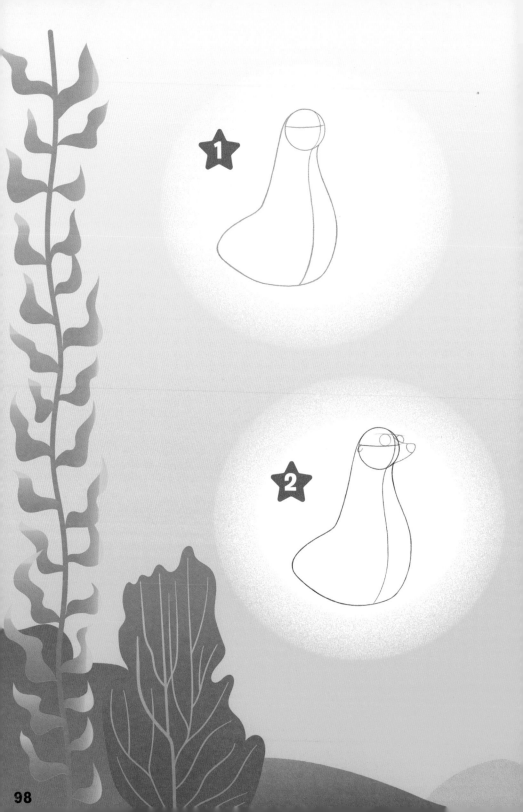

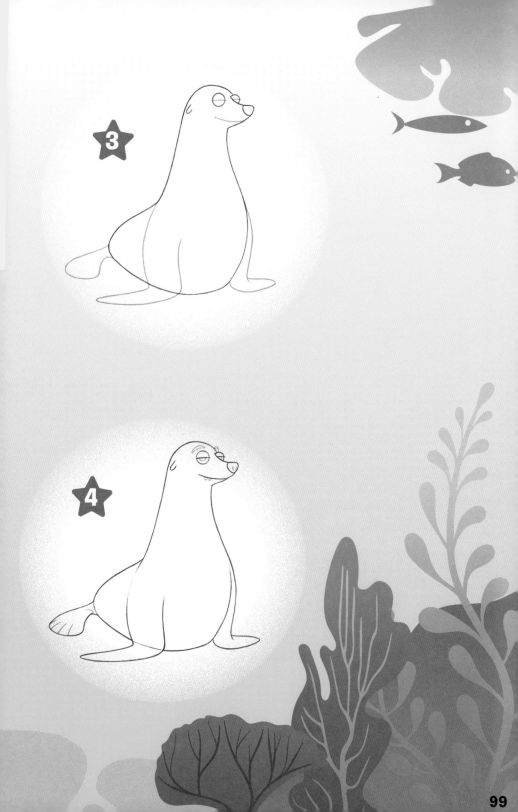

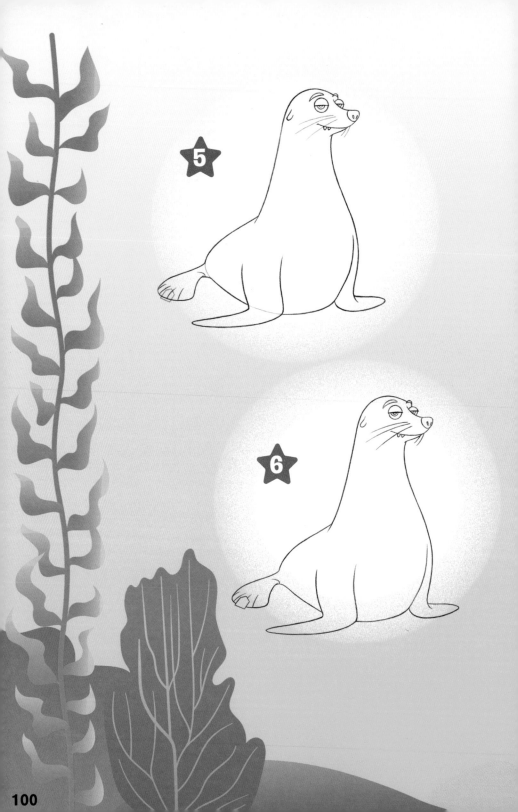

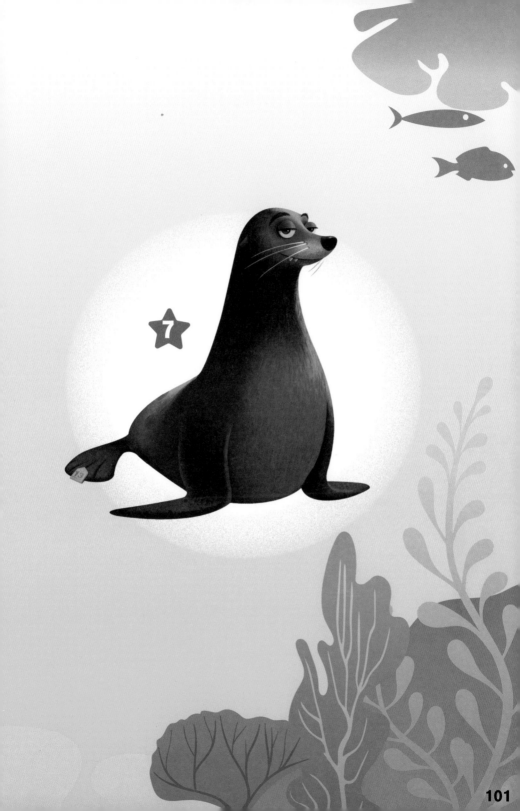

Try drawing Rudder here:

Rudder's rear fins
are rubbery and have
5 individual toes

Draw eyelids that overlap the
eye to give it some thickness

Gerald

Gerald is an offbeat sea lion who carries a green pail. All he wants is a seat on Fluke and Rudder's rock, but they're constantly telling him to shove off!

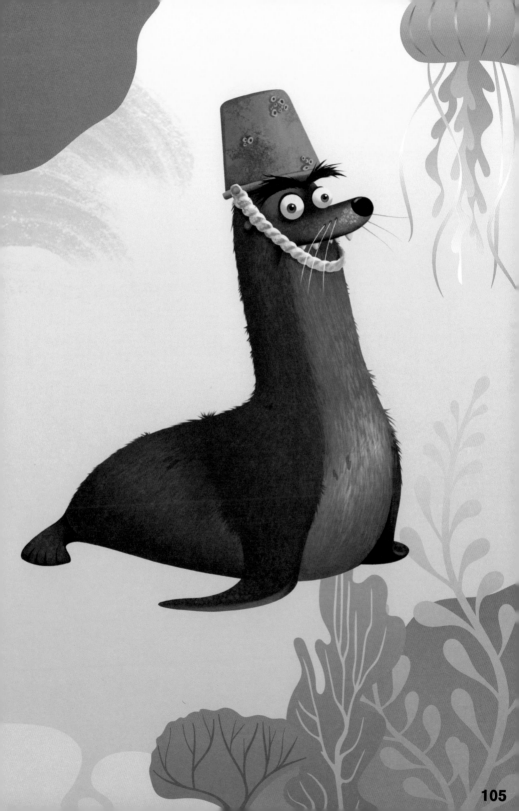

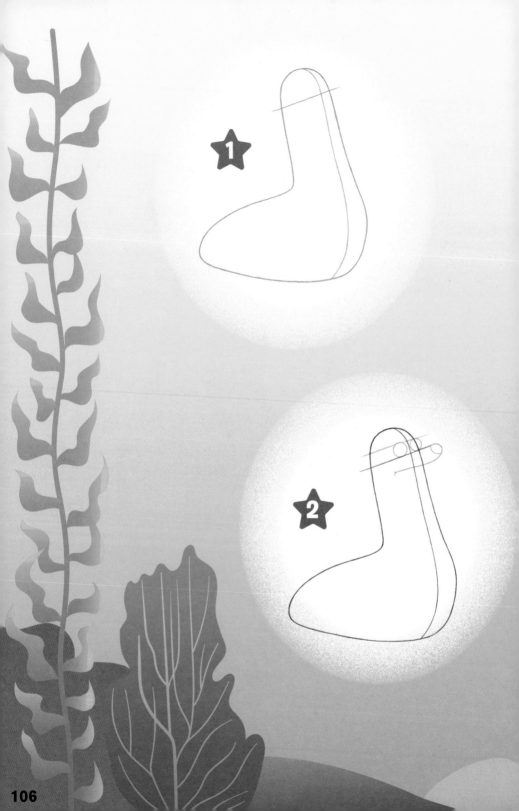

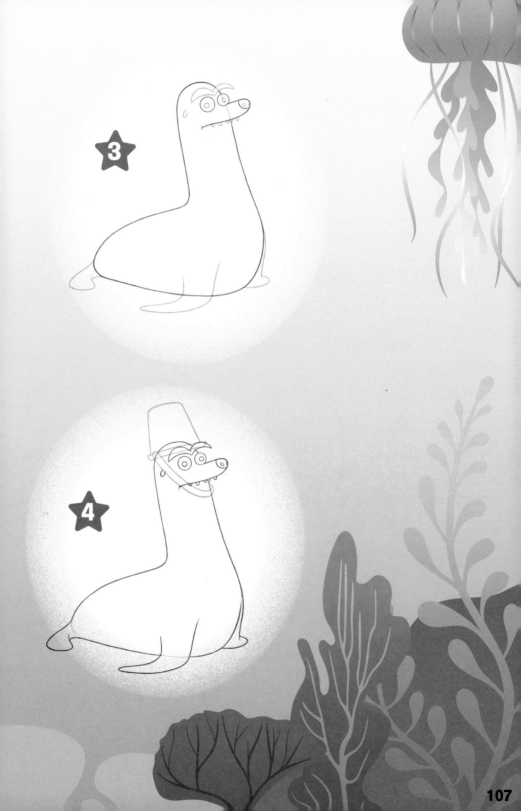

107

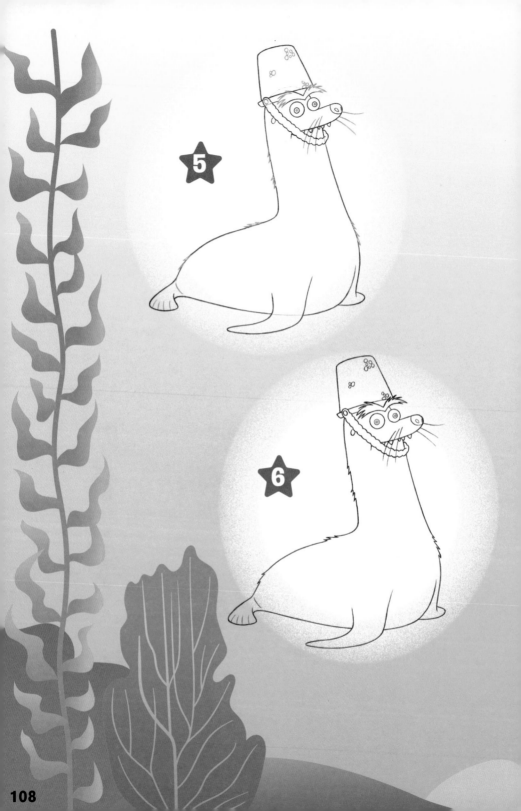

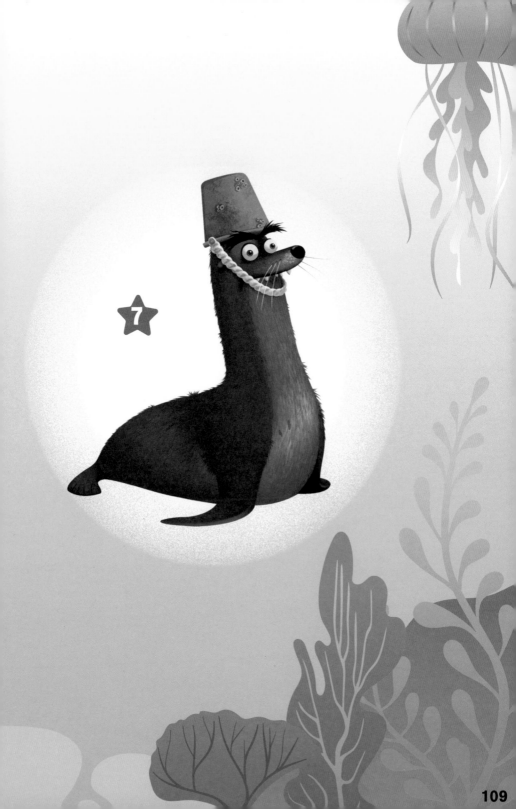

Try drawing Gerald here:

Becky

Becky is a quirky loon who imprints on Marlin. While Becky is a reliable friend, she's also easily distracted—a trait Marlin isn't too pleased about! Carrying Marlin and Nemo in Gerald's pail, she flies the two clownfish into the Marine Life Institute to find Dory.

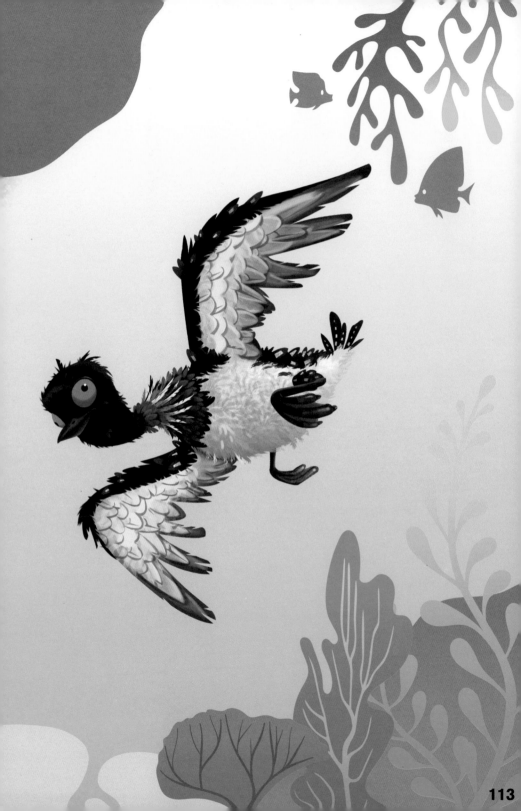

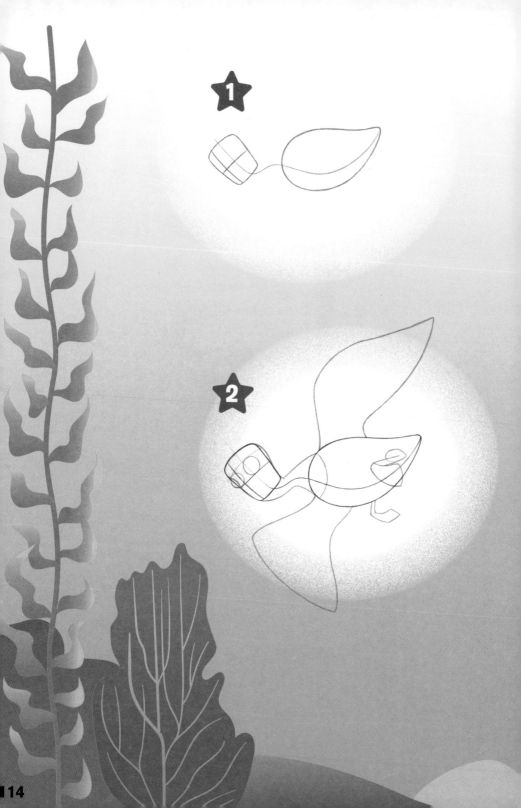

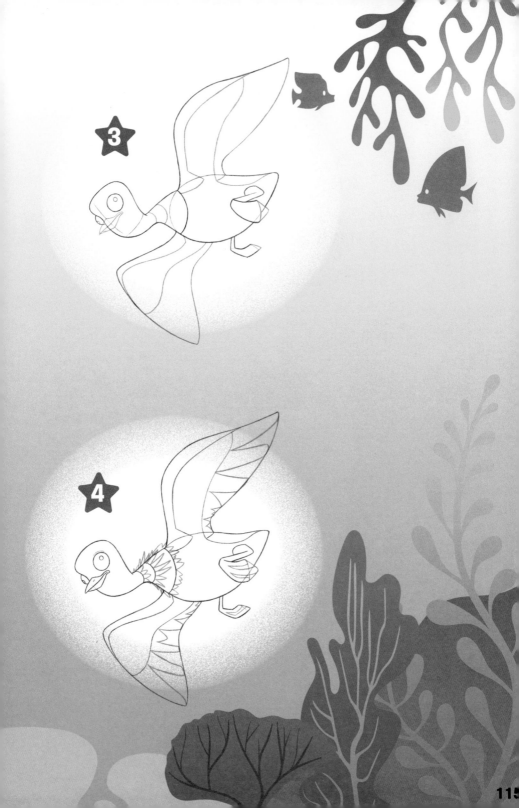

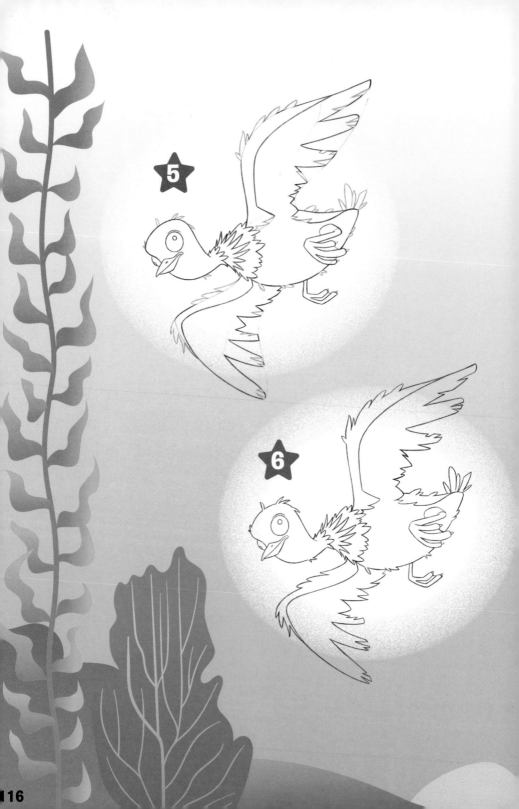

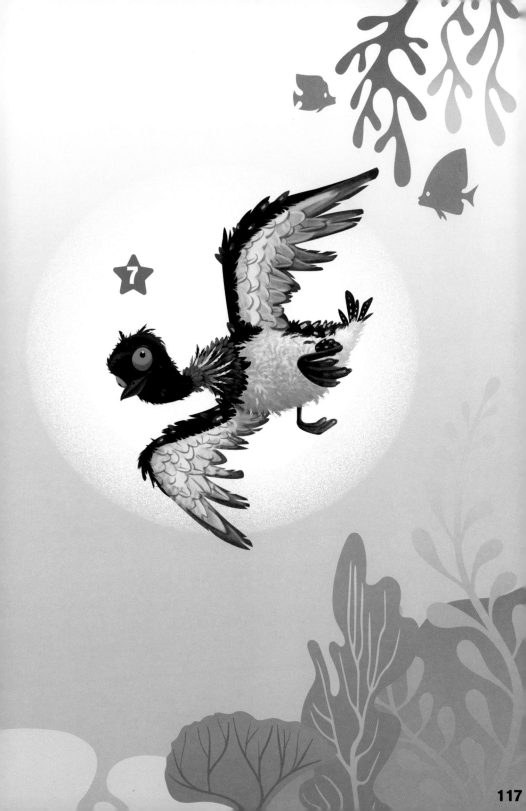

Try drawing Becky here:

Otters

Adorable and furry, the otters live both inside and outside the Marine Life Institute. They love to hug and frequently have "cuddle parties" that make spectators *ooooooh* and *awwwww*. They're so adorable—they literally stop traffic!

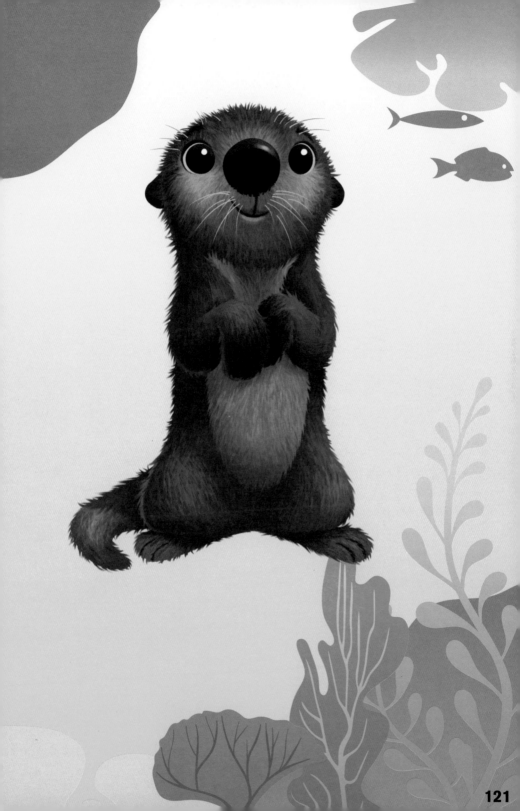

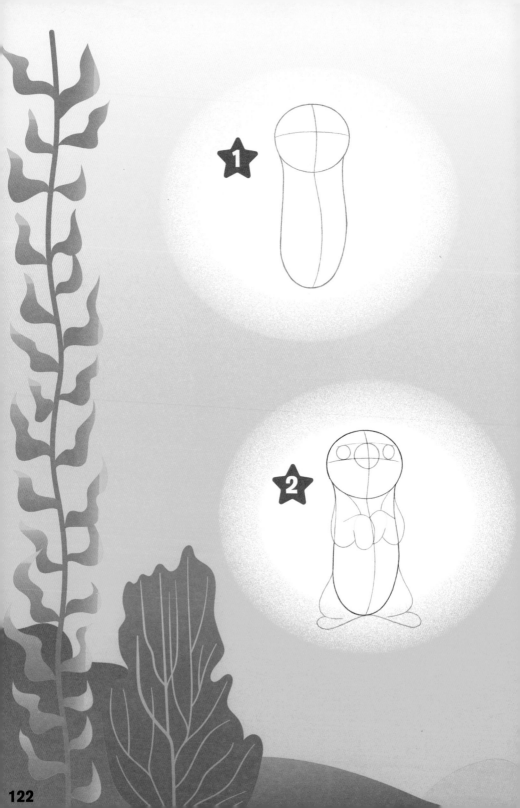

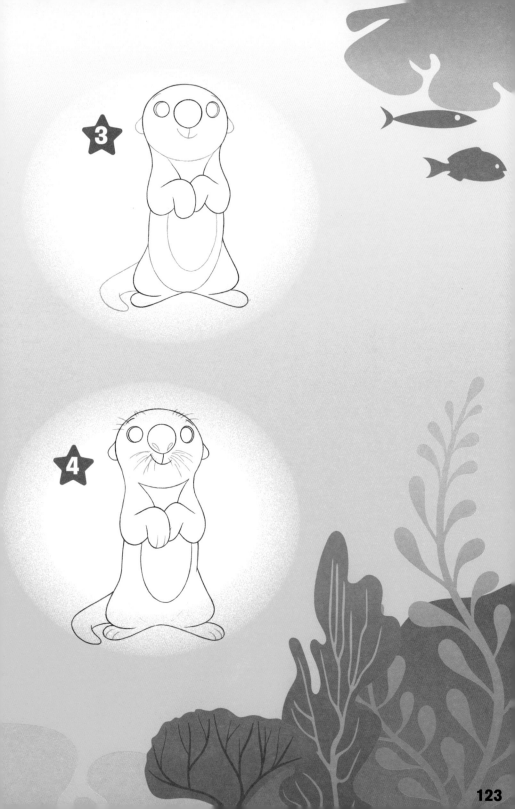

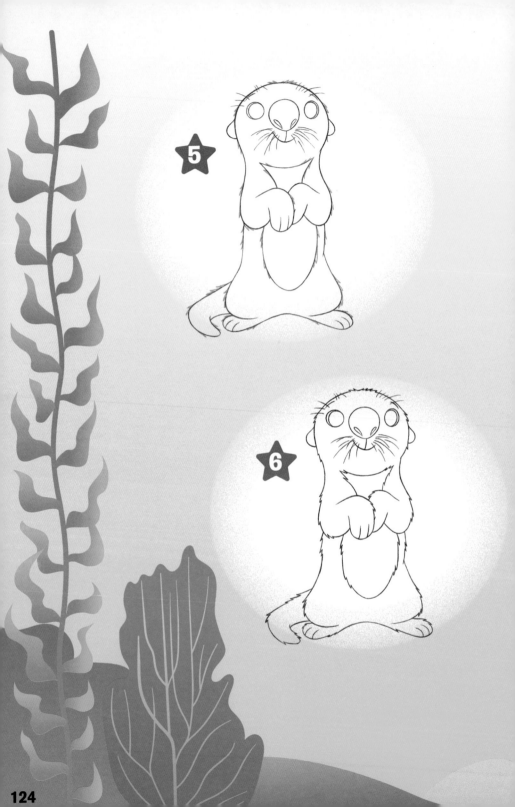

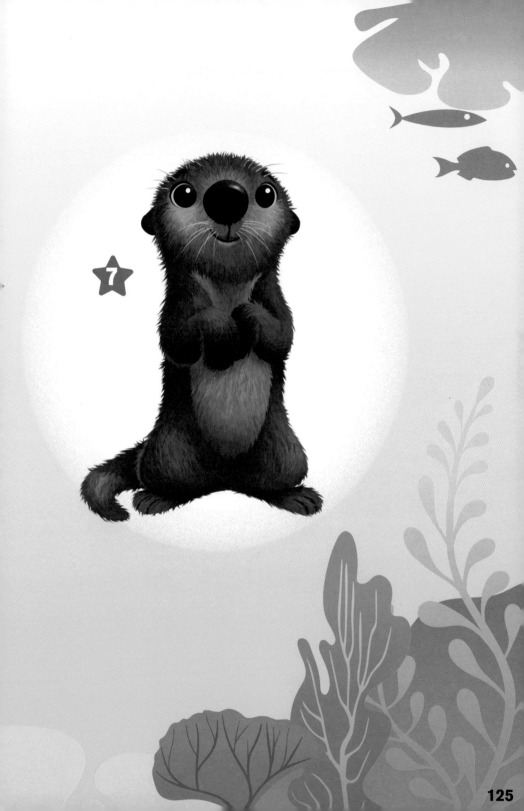

Try drawing an otter here:

The End

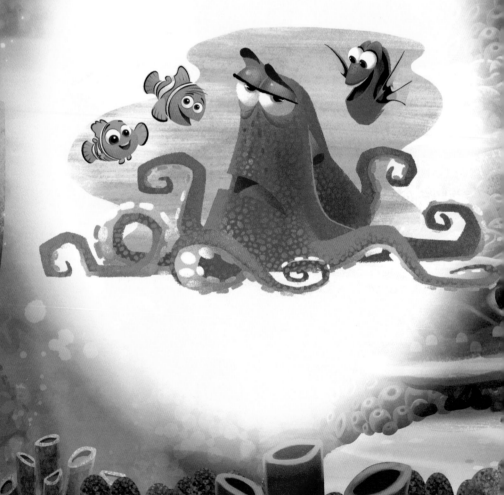